[CREATive WATercoLor]

step-by-step guide and showcase

BY MARY ANN BECKwith

with LORie M. LiebRock

Rockport Publishers, Inc. • Rockport, Massachusetts
Distributed by North Light Books, Cincinnati, Ohio

First published in the United States of America by:
Rockport Publishers, Inc.
146 Granite Street
Rockport, Massachusetts 01966-1299
Telephone: (508) 546-9590
Fax: (508) 546-7141

Distributed to the book trade and art trade in the United States by:
North Light, an imprint of
F & W Publications
1507 Dana Avenue
Cincinnati, Ohio 45207
Telephone: (513) 531-2222

Other Distribution by:
Rockport Publishers
Rockport, Massachusetts 01966-1299

ISBN 1-56496-172-9

10 9 8 7 6 5 4 3 2 1

Art Director: Lynne Havighurst
Designer: Kristen Webster Hemmer
Editor: Shawna Mullen
Front Cover Image: *Incha's Gift* by Mary Ann Beckwith
Back Cover Images: *(left to right) Royal Cyclamen,* by Warren Taylor
Daystar, by Maxine Masterfield
Cheboygan River Lighthouse, by Mark E. Mehaffey
Title Page Image: *Earth Angel,* by Barbara J. Hranilovich
Table of Contents Image: *Yellow Brick Road,* by John F. Adams
Introduction Image: *Untitled,* by Mark Browning
Additional Photography: Bonnie L. Burke, *page 10*
Doug Cannon, *page 64*

Manufactured in Singapore by Regent Production Services Pte. Ltd.

[DEDICATION]

This book is dedicated with love to Phil, Susan, and Carl, for helping, believing, and being.

[ACKNOWLEDGEMENTS]

Special thanks to Vera, for believing that I could do this.
...to Lorie and NiKi for helping me to do this.
...to my friends for sticking by me while I did this.
And a very special thank you to all the artists both in this book and those
who submitted work for consideration—without you, this book could not exist.

[table OF contents]

[i n t r o d u c t i o n]

Writing a step-by-step guide implies art can be produced by formula or recipe. It suggests artists always produce their work by some predictable process that can be recorded and duplicated. The artists in this book recorded techniques used to create some of their works. They may never use this same succession of steps or even the same process in another painting. In truly creative processes, the first step dictates the succeeding steps. Each piece of art will progress in an individual way; none will duplicate the process of another.

The constant stream of new materials influences the artist's process. Pigments are prepared in a multitude of forms to give artists new options. Inks with incredible color intensity and permanence are now available to artists. Dry pigments with binders provide artists with unbelievable color options. New, light-fast, color saturated watercolors are produced in liquid state, premixed for the artist. Watercolor pigments are compressed into stick and pencil form to give the artist completely new application possibilities. Improved papers and painting boards provide a rich variety of flexible painting surfaces. Old art tools, like mouth atomizers, have new applications. They are used to spray color or even to spray masking fluids. Products, such as acrylic floor wax, alcohol, wax paper, Saran wrap, and polymer mediums are part of the artist's new inventory. Artists

new inventory. Artists are reaching into basement tool boxes to pick up a heat gun or a Dremel and achieve new effects.

A wide variety of working surfaces also affect the results in watercolor. Artists use hot press, slick-surfaced paper, for puddling and granular effects. Cold press paper, great for textures, provides an all-round surface. Paper is sized to give resistance or make paint sit on the surface rather than allowing it to be absorbed. On different surfaces, identical techniques respond with amazingly different results.

Art supplies are no longer bought only in art stores. Craft stores, grocery stores, and malls sell items made for one use and artists use these items to create textures, patterns, and marks on the surfaces of their work. Halloween cobwebs texture a paper surface. Easter grass pressed into wet pigment produces dried leaf or rock-like textures. Holiday tinsel produces a linear texture and could be used to simulate tall grasses or reeds. Color saturated string produces lines and shish-ka-bob sticks make marks with pigment. Lace may be used for a stencil and for the transfer of pigment. Gauze may be used with a dry brush technique to paint around the strands or saturated with pigment to transfer its pattern to a painting. Saran wrap is used for more than leftovers, it is an agent to transfer textures to the painting surface. No artist will use these effects in the same way and none will be limited to traditional brush concepts.

Technology changes the ways we produce our work. Computers, laser imaging, and Xerox equipment are used to generate, transfer, and print images. This technology provides the artist with numerous options.

Tried and tested techniques of glazing (layering transparent washes of color one over another), layering (building opaque or semi-opaque passages one over another), spattering, sponging, masking, printing, and pouring of paints are used in a variety of images and personal statements. Very traditional images are produced using the most unusual techniques. The most outrageous subjects are painted using very traditional methods.

Today creative watercolor has no limits, no boundaries. Artists are less resistant to change; materials are updated, improved, and available at astounding speeds.

While technology is changing, we must be ever aware of the added concerns associated with the materials we use. Exposure to chemicals and pigments can be dangerous if precautions are not taken. Pigments vaporized in the air with the mouth atomizer or airbrush, require, at a minimum, excellent ventilation, or, at best, the use of a respirator. The vapors from drying pigments with a heat gun may present hazards and caution should be used. Pigment can even be absorbed through the skin. Utmost caution must be used with any experimental technique. Rubber gloves, respirators, and safety glasses may be a necessary part of the process as well.

The steps, materials, tools, and processes illustrated in this book provide a starting point for your own explorations. Innovative approaches to watercolor encourage total spontaneity and freedom from rules, steps, or predictable processes. We hope the step-by-step demonstrations and the innovative showcase images serve as a springboard and inspiration for all of you.

[SECTION ONE: techniques inspired by nature]

Paths of tiny, unknown creatures in the drying mud of a spring puddle. Stains of fallen leaves upon the sidewalk. Patterns of waves in dried beach sand. Ice crystals forming on a window on a blustery winter morning. These natural patterns pique the curiosity of many. Some artists put these natural phenomena to work for them.

Sources of inspiration for artists include wind, rain, cold, and other natural phenomena too numerous to list. Artists in this section utilize natural effects to attain images with unending possibilities.

The extreme winter temperatures in Michigan's Upper
Peninsula help Kathleen Conover Miller produce ice crystal paintings.
A full-time studio artist, Conover Miller has received numerous awards
and is a signature member of the Midwest Watercolor Society.

*"Ice patterns on a pond surface, cracked ice on a puddle, frost
on my kitchen window are all patterns which intrigue me and
inspire me to explore further the results of freezing pigment and
leaving these patterns as permanent marks on the paper."*

-Kathleen Conover Miller

[ice crystals]

"Technique is not an end in itself but a starting point providing visual complexities from which to further develop the piece." For Conover Miller, the preparation of materials and patient waiting for the perfect temperature conditions are part of the process. Watercolors and the more intense permanent inks are perfect for the techniques she employs and the results she strives to obtain. For this process, ideal temperatures are between 10 and 20 degrees Fahrenheit. Temperature dramatically affects crystal growth—if the temperature is above 25 degrees, the pigment settles into the paper before crystals form, and no pattern will appear. The demonstrations that follow will show how she creates paintings with ice crystals, which are formed by nature.

[*i*CE *r*APt]

MATERIALS

- 140# hot press watercolor paper
- Tube water colors: Prussian Blue, Cerulean Blue, Mineral Violets, and Raw Sienna. Liquefy each color separately in a blender, with enough water to evenly disperse the pigment and ensure a smooth consistency. Store in bottles.
- White casein
- Leaves
- Sponge
- Chalk
- Blender
- Palette knife
- Watercolor brushes
- Tissue or paper towel
- Squeeze bottles for storing colors
- Toothbrush

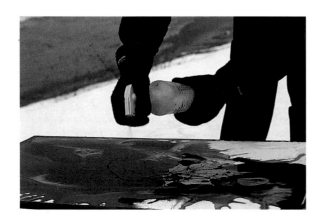

1 Working outdoors on a flat surface, the artist pours water over a 22- by 30-inch (55.9 cm by 76.2 cm) piece of hot press watercolor paper, then pours off the excess so that no puddles remain on the surface. Leaves are put down on the paper, to act as a loose resist to the wet pigment, and the pigment is poured onto the surface. Alternatively, paint may be quickly squeezed onto the surface from squirt bottles. The pigment will rapidly begin to freeze. Beware—attempts to rework, with a brush or by adding more pigment, will disrupt the crystal patterns. The painting should be left flat and undisturbed while the crystals form. Falling snow, sunlight, or wind may disturb the surface and inhibit crystalline formation.

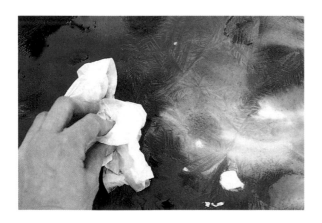

2 After several hours of freezing the painting outside, it is brought into the studio to thaw. A clear crystalline imprint will remain in areas that have freeze-dried completely. In other areas, freeze-drying may not be complete, so water must be mopped up gently with tissues or paper towels (without disturbing the fragile patterns) as those areas thaw. When the painting is completely dry, it is examined from all directions to assess its design possibilities. After top and bottom are determined, value study sketches help determine the direction of development, mapping the areas of light and dark that best suit the subject suggested by the frozen patterns. Chalk lines are used to transfer the sketch to the painting: chalk serves as a removable guideline.

3 Lifting of pigment or scrubbing lightens some parts of the painting and emphasizes the cracked ice imagery. The area to be lifted is moistened with water, scrubbed with a toothbrush or sponge to loosen pigment, and wiped gently with a tissue or paper towel to remove the pigment.

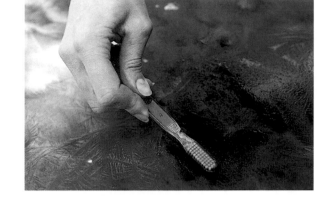

4 The interesting puddles left behind by the natural leaves are enhanced at this stage. They will appear as partially hidden, ice-trapped leaves in the final piece. A leaf pattern is printed directly on the painting's surface by covering a real leaf in white casein and then pressing it down. When working transparently, the leaf can be used as a stencil and sponged around the edges (absorbing the paint) to create a leaf shape. The sponged area will be lighter than the area covered by the leaf. Conover Miller uses these same techniques with other objects, such as feathers.

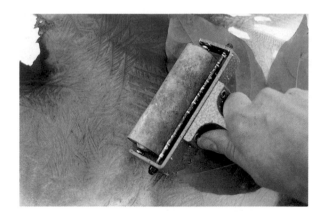

5 In the final stage, areas are painted with more saturated pigment to enhance the light, medium, and dark design structure of the composition. Conover Miller carefully brushes a wash of saturated color on areas she wishes to darken, taking care not to disturb the delicate crystals. The chalk lines are gently removed using a kneaded eraser.

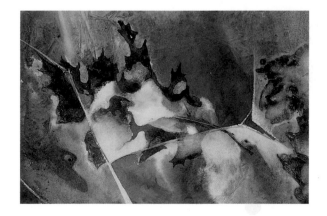

[artist's portfolio]

"In painting, as in nature, the best work is created when the structural elements and organic forms are in harmony."

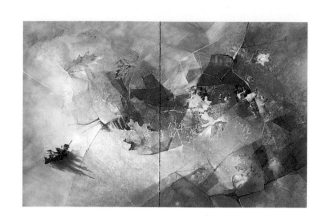

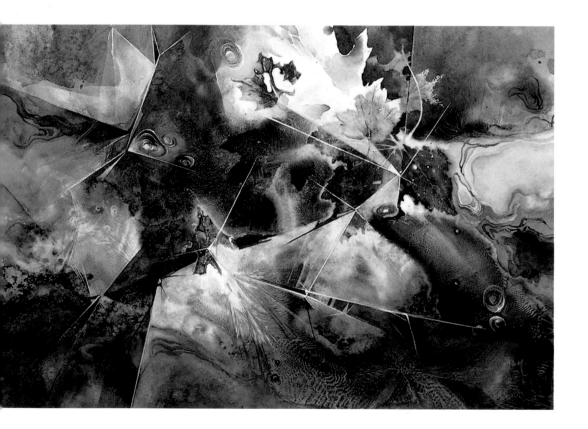

(top) **Winter Fragments**
30" x 44" (76.2cm x 111.7cm)
Technique: Ice crystal painting

(left) **Night Freeze**
22" x 30" (55.9cm x 76.2cm)
Technique: Ice crystal painting

(top right) **Vestige**
22" x 30" (55.9cm x 76.2cm)
Technique: Ice crystal painting

(bottom right) **Silent Motion**
22" x 30" (55.9cm x 76.2cm)
Technique: Ice crystal painting

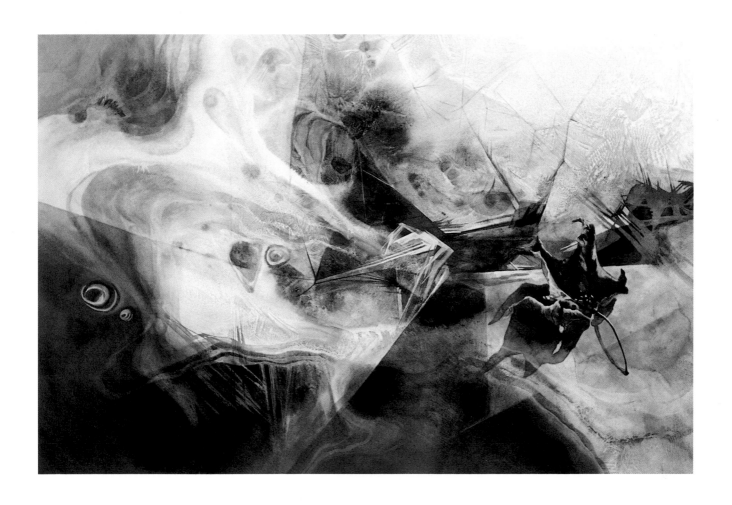

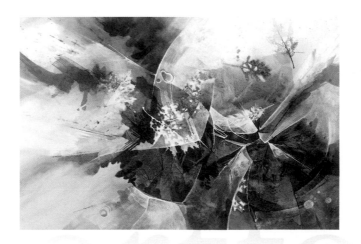

[s h o w c a s e]

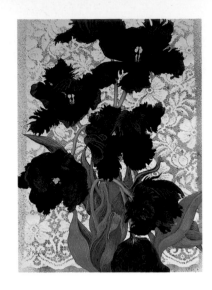

(left) Judi Betts
In Memory of...
30" x 22" (76.2cm x 55.9cm)
Paper: Arches 140# cold press watercolor paper
Technique: Light shapes saved, midtones painted, darks added, lifting, scrubbing of lights

(top) Rosemary S. Antel
Black Parrot Tulips
30" x 22" (76.2cm x 55.9cm)
Paper: Arches 140# hot press watercolor paper
Technique: Lace stenciling, direct painting

(top right) Betty Braig
A Place in Time
40" x 30" (101.6cm x 76.2cm)
Paper: 2-ply Crescent hot press board
Technique: Pouring acrylics onto wet surface, watercolor, direct painting

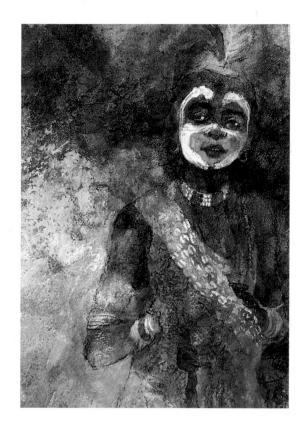

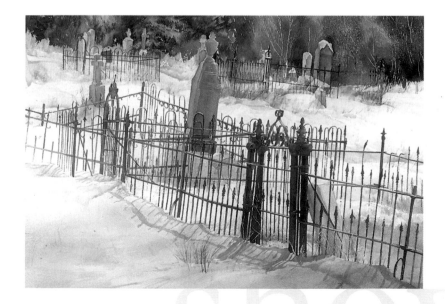

(top) Leslie Clark
Red Feather
12" x 9" (30.5cm x 22.9cm)
Paper: Indian Village cold press watercolor paper
Technique: Pouring, direct painting, pressing paint
with fingertips

(left) Kass Morin Freeman
Tombstone Territory, Dillon Co.
27" x 38" (68.6cm x 96.5cm)
Paper: Arches cold press watercolor paper
Technique: Contact paper stencils, glazing, use of salt
and razor

showcase

(left) Patry Denton
Follow the Bouncing Ball
30" x 22" (76.2cm x 55.9cm)
Paper: Crescent 5115 hot press board
Technique: Watercolor, wet-on-wet, pouring paint, direct
painting, lifting

(top) Maggie Linn
Wild Strawberries on Mosses and Lichens
15.5" x 18" (39.6cm x 45.7cm)
Paper: Arches 90# paper
Technique: Color dropped on surface, accidental effects,
direct painting

(top right) Bill James
Flea Market
26" x 20" (66.1cm x 50.8cm)
Paper: Hot press illustration board
Technique: Gesso sized, direct painting, lifting

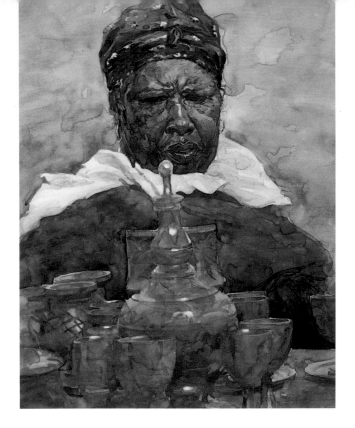

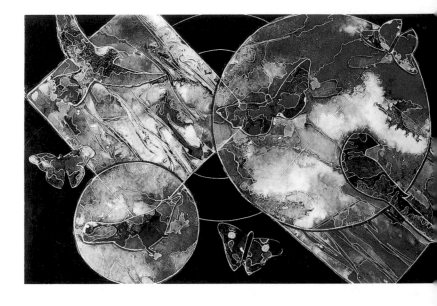

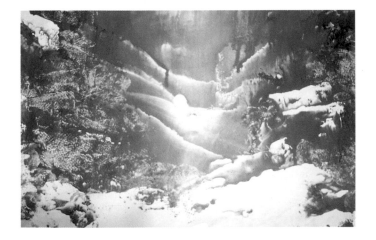

(top) Virginia L. Gould
The Nature of Things
14" x 21" (35.6cm x 53.3cm)
Paper: Morilla board #1059
Technique: Ink pouring, plastic shapes dropped then left
to dry and removed, white ink lines

(left) Betty Grace Gibson
Somewhere in the Enchanting World
14" x 18" (35.6cm x 45.7cm)
Paper: Arches #88 watercolor paper
Technique: Tube watercolors, dry pigment, liquid
watercolors, pouring, splashing with white

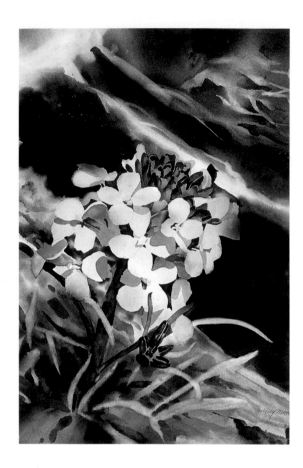

(left) Wendy Mattson
The Earthbound Wake
31" x 44" (78.7cm x 111.8cm)
Paper: Arches 300# cold press watercolor paper
Technique: Wet-on-wet, lifting, direct painting

(bottom) Glenda VanRaalte
Speak No Evil
32" x 24" (81.3cm x 61cm)
Paper: Mulberry oriental paper
Technique: Mulberry paper, batik on paper, masking, stenciling, direct painting

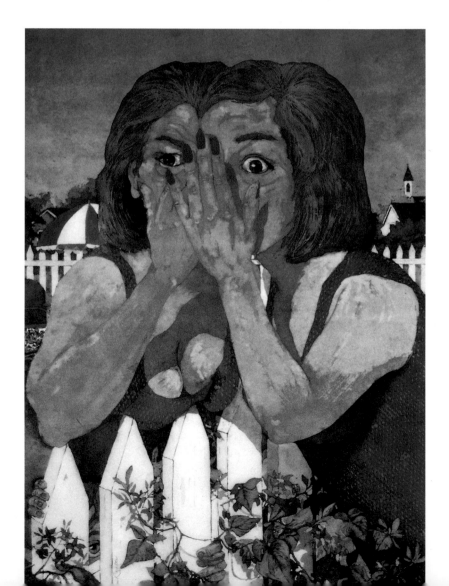

(top right) Robert Lee Mejer
EMW: Mosaic
30" x 22.5" (76.2cm x 57.2cm)
Paper: Arches 300# watercolor paper
Technique: Sponge, scrape, stencil, stamp

(far right) Donna Jill Witty
Migration
22" x 30" (55.9cm x 76.2cm)
Paper: Arches 140# cold press watercolor paper
Technique: Freezing, positive and negative painting

(bottom right) Carole Myers
Dark Passage VIII
30" x 40" (76.2cm x 101.6cm)
Paper: Bainbridge illustration board
Technique: Direct painting, stamping, lifting, scraping

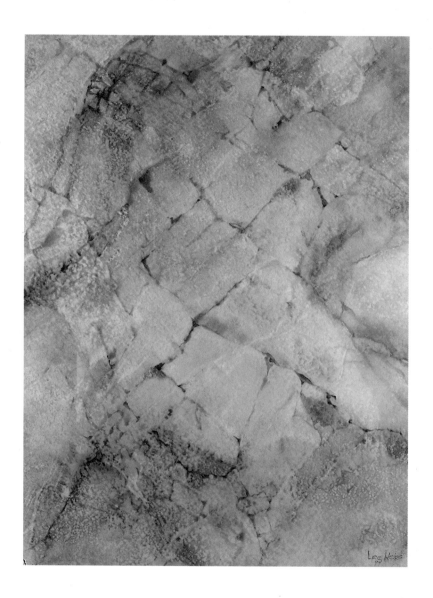

*Lee Weiss is a full-time painter who has made enormous contributions
to the world of watercolor. A respected teacher and juror, Weiss is a
member of the American Watercolor Society and holds the
prestigious title of Dolphin Fellow.*

"Working wet into wet, I am free to let the watercolor medium lead me. My subject matter is given by ever-generous nature, but even when I know what I want to portray, I am prepared to abandon that idea in favor of the pure joy and unexpected beauty that flows from the brush."

-Lee Weiss

[tHe FLip siDe]

"**I** seek to create rather than recreate. Watercolor collaborates." At some time every artist looks at the surface of their palette at the end of a day of painting and wishes they could duplicate those beautiful colors, mixtures, and spontaneous puddles on the surface of the paper before them. Spilled puddles of paint can be transformed into artists' materials by pressing a piece of paper into the pigment. The traditional, "I'm going to the studio to paint" evokes the image of artists applying paint to the paper's surface automatically, we envision brushes carefully manipulating pigment in preordained spaces. Yet, Lee Weiss' work goes far beyond that.

[*l* a T *e* C A N *y* o N L *i* G H *t*]

MATERIALS

- Morilla roll paper #1059R 42" x 10' (106.7cm x 304.8cm) (Recently changed to Cap Tanson 701-0001) Chosen for its heavy weight, random texture, and rough and smooth surfaces on alternate sides.
- Slick table top or sheet of Plexiglas larger than the paper
- Winsor & Newton tube watercolors: Raw Sienna, Burnt Sienna, Raw Umber, French Ultramarine Blue, and others necessary to modify color
- Absorbent cardboard surface (beaver board)
- X-ACTO knife for trimming paper

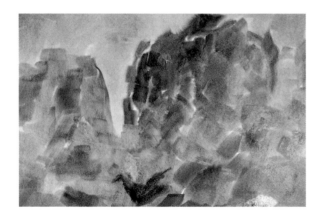

1 Lee Weiss' work is often inspired by the results as they appear on the paper. After thoroughly wetting the paper surface several times with a large brush and moving out the corner tapes to keep the paper surface and edges flat as it "relaxes," Weiss removes the tapes and wets the corners. It is important not to let water creep under the edges. On the wet surface, she paints boldly designed, strongly colored areas, wet-on-wet. This painted surface "side A," is the rough side, and the unpainted side, facing down, is "side B." Weiss turns side A down on a slick-surfaced table.

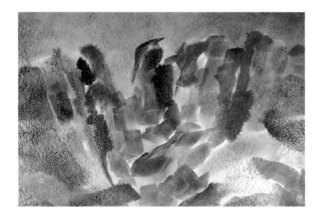

2 With side A still wet, Weiss wets side B, now face up, with water. Weiss applies wet paint again; approximating basic elements from the other side but not worrying about accuracy and deliberately altering colors and shapes enough to add excitement to subsequent layering. It is not necessary to tape the corners of side B because the paper is now thoroughly stretched and relaxed.

3 Turning side B down ("flipping" it end-over-end and always turning in the same direction), side A is now up, leaving behind a lot of the pigment on the table surface. The paint deposited on the table "prints" onto side B. She applies more pigment to side A.

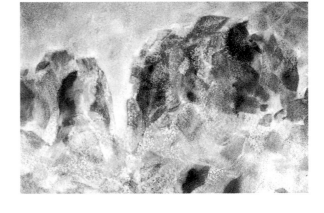

4 Turning again (side B up), notice how much intensity of color is "lost" to the table and "printed" on the opposite side. Outlines blur and textures build with each subsequent turn. Weiss adds more pigment and structure before turning again. To develop side B into a painting, Weiss begins adding detail (strata demarcation). She turns the painting again to integrate and add further texture, NOT painting on side A at this point, merely using the paint on the table to continue to build texture and interest. Both the paper and the table-paint begin to dry and make defined texture.

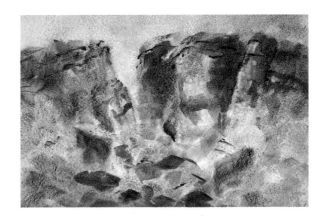

5 After additional flipping of the piece, Weiss brushes out unwanted texture in the sky, nearly lifting back to the white of the paper. The sky is somewhat stained by the original application of strong color so it retains the warmth and the appearance of the "light source" intended. She also lifts color from the surfaces of rocks that would logically be struck by the light source and darkens the crevices in the rocks. The painting is moved to a flat surface to dry and be trimmed. Weiss then paints directly to complete the image, layering darker washes and adding accents as desired.

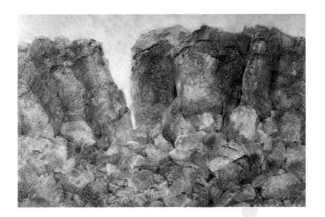

{ar

foLio}

t a painting—it has to be
a more or often less important part of one."

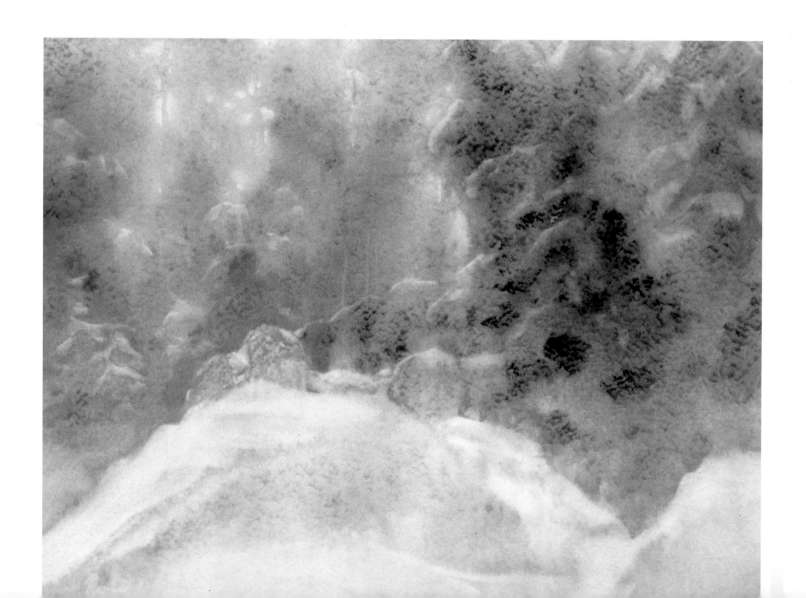

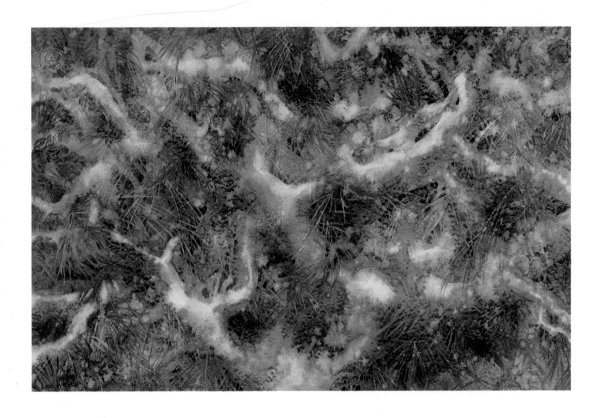

(left) Snow Laden
32" x 40" (81.3cm x 101.6cm)
Technique: Repeated wet-on-wet printing

(top) Pine and Snow
27" x 40" (68.6cm x 101.6cm)
Technique: Repeated wet-on-wet printing

(right) Morning River Mist
27" x 40" (68.6cm x 101.6cm)
Technique: Repeated wet-on-wet printing

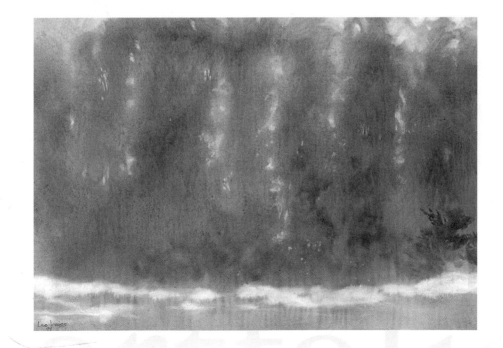

[s h o w c a s e]

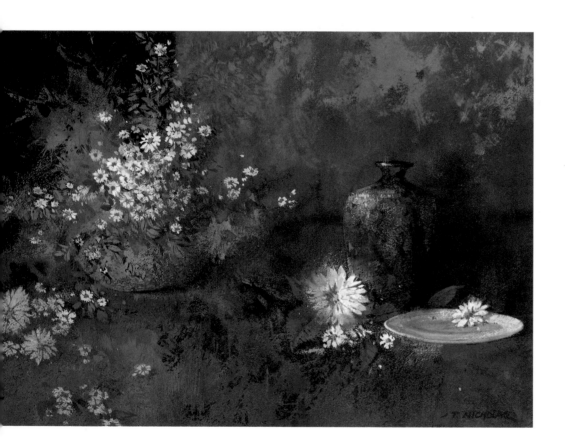

(top) Carol A. Hammett
Moon Touched
11" x 11" (27.9cm x 27.9cm)
Paper: Aluminum lithographic plate
Technique: Monotype, acrylics on aluminum plate

(left) Thomas Nicholas
The Lapis Vase
6.5" x 8.5" (16.5cm x 21.6cm)
Paper: Lanaquarelle 300# cold press watercolor paper
Technique: Monoprint, semi-opaque pigment

(top right) Carol A. Hammett
Entangled Illusions
12" x 12" (30.5cm x 30.5cm)
Paper: Aluminum lithographic plate
Technique: Monotype on aluminum plate, acrylic paint

(far right) Alex Koronatov
December in California
28" x 36" (71.1cm x 91.4cm)
Paper: Arches 300# rough watercolor paper
Technique: Watermedia, direct painting, wet-on-wet, lifting

(bottom right) Yolanda Frederikse
Potomac Boathouse from Key Bridge
25" x 35" (63.5cm x 88.9cm)
Paper: Rives BFK paper
Technique: Watercolor monotype

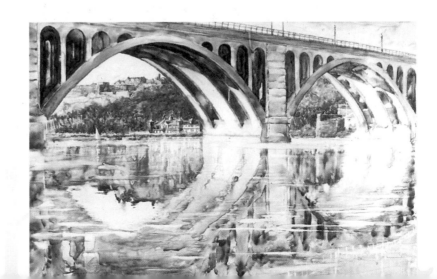

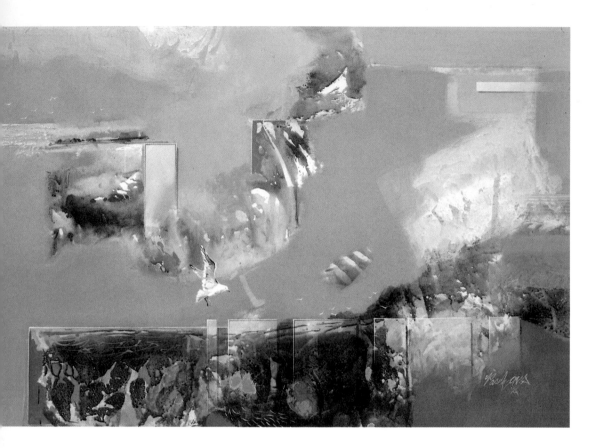

(left) Doug Pasek
California Breeze
28" x 36" (71.1cm x 91.4cm)
Paper: Strathmore Crescent 114# watercolor board
Technique: Acrylic, cloth imprint, direct painting

(bottom) Frank Francese
Harrah's Las Vegas
22" x 30" (55.9cm x 76.2cm)
Paper: E.H. Saunders 140# Waterford Series watercolor
paper
Technique: Splashed washes, wet-on-wet, scraping,
calligraphy

(top right) Catherine Wilson Smith
#1 Summer Gemstone
22" x 30" (55.9cm x 76.2cm)
Paper: Arches 140# rough watercolor paper
Technique: Direct painting, wet in wet

(far right) Gloria Miller Allen
Canyon Wall #28 Zion Crevice
22" x 30" (55.9cm x 76.2cm)
Paper: Arches 140# cold press watercolor paper
Technique: Wet in wet, direct painting

(bottom right) Peggy Brown
Duet
26" x 40" (66.0cm x 101.6cm)
Paper: Rives lightweight
Technique: Watercolor, wet-on-wet, powdered charcoal,
graphite, watercolor pencils

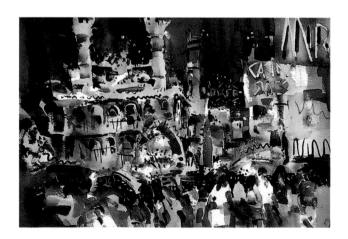

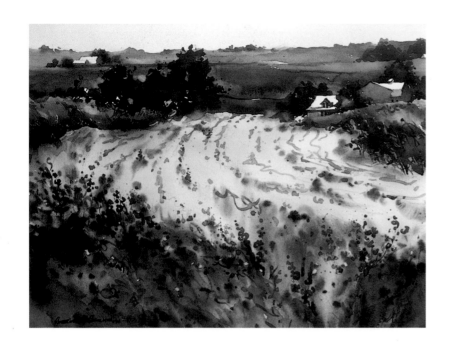

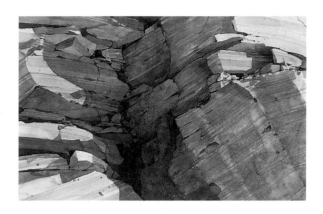

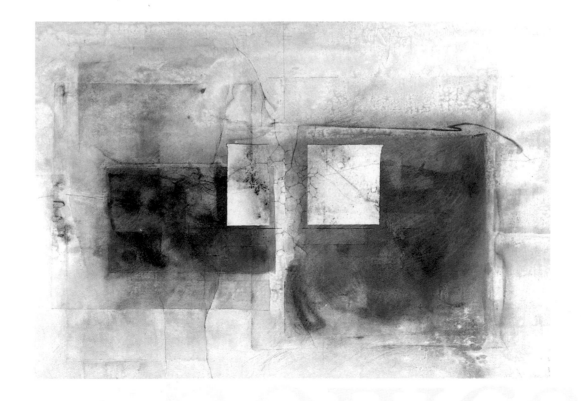

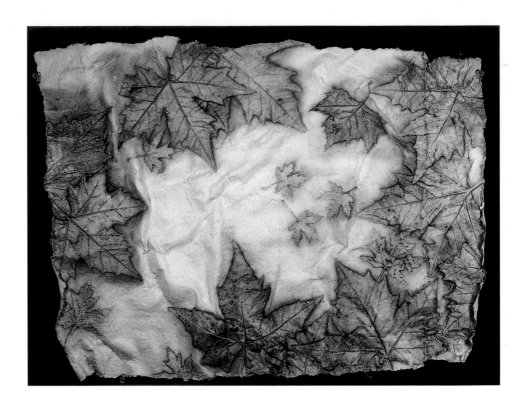

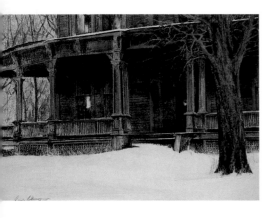

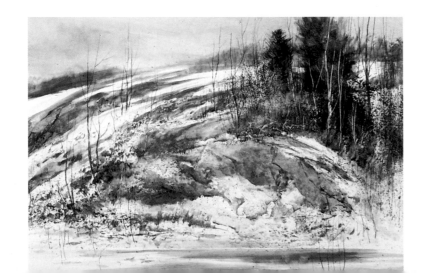

(top) Lorie M. Liebrock
Fallen Colors
22" x 30" (55.9cm x 76.2cm)
Paper: Handmade paper
Technique: Watercolor printing during creation of handmade paper

(far left) George Sottung
Snowline
19" x 25" (48.3cm x 63.5cm)
Paper: Bainbridge 172# watercolor board
Technique: Acrylic, wet-on-wet, direct painting

(left) Murray Wentworth
Frozen Ridge
25" x 35" (63.5 cm x 88.9cm)
Paper: Strathmore high-surface illustration board
Technique: Pressed acetate sheets into wet washes of color

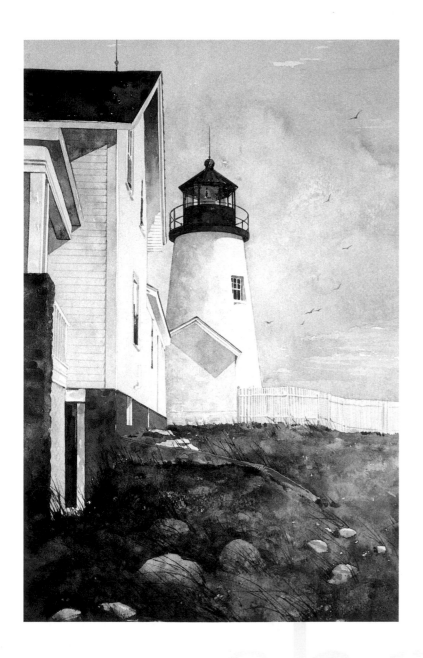

(right) Elaine Wentworth
Rock Bed
20" x 30" (50.8cm x 76.2cm)
Paper: Strathmore high-surface illustration board
Technique: Spattering, glazing, printing with acetate sheets, watercolor

(left) Terry Wickart
Pemaquid Point
17" x 11" (43.2cm x 27.9cm)
Paper: Fabriano 140# cold press watercolor paper
Technique: Wet-on-wet, direct painting

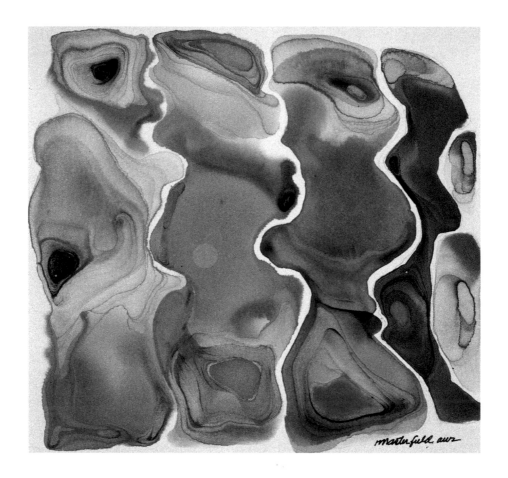

*Maxine Masterfield is dedicated to exploring and expanding the possibilities
of watermedia. A graduate of the Cleveland Institute of Art, she is a
nationally-known artist, respected teacher and juror. She is an active member
of the American and National Watercolor Societies and a founding
member of The Society of Experimental Artists.*

"I taught a workshop in a building with a leaky ceiling. Early in the week it had been raining and each day as I passed the ceiling I noticed a pattern evolving. I realized that heat, not just the water drying, was an important part of the process. The ceiling pattern became my inspiration and the method by which it was formed became my goal."

-Maxine Masterfield

[h e *a* t w *a* v e s]

"If a pattern exists in nature, it can exist in art." Maxine Masterfield's experimental techniques are driven by her need to reproduce the patterns she finds all around her. Inspired by these patterns, she uses any materials to achieve a certain image. Sand, wax resist, solar energy, unusual rocks, fibers, and tissue paper are just a few of the unusual elements she uses to transform pigment into pattern. The desire to recreate this water stain pattern, as well as others found in nature, drives Masterfield to search for unconventional tools to reproduce those intriguing patterns. Tools, more often found in a basement workshop than in an artist's studio, assist her in reproducing natural effects in her paintings.

[together]

MATERIALS

- Strathmore heavyweight illustration board #500 Series, plate finish
- Inks, watercolors, or acrylics (thinned to a fluid solution) Antelope Brown, Indigo Blue
- Heat gun
- Containers for water

1 Masterfield begins with a sheet of illustration board that is 100 percent cotton fiber mounted on two sides. This board has a balanced tension and does not warp when saturated. She pours a small quantity of water onto the surface of the paper and adds 1 to 2 tablespoons of Antelope (brown) ink to the resulting puddle. In this demonstration, ink is used; watercolors or thinned acrylics work in a similar way, but are not as intense. Masterfield recommends working small (10 x 10 inch, 25.4 cm x 25.4 cm) and with just one color pigment until you have mastered the technique.

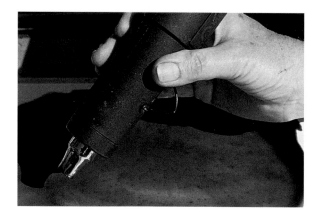

2 She begins heating the edge of the colored water. Holding the heat gun at a right angle and 1 to 2 inches from the paper, she moves the tool slowly along the edge: this begins to dry the water. Her objective is to "rock" the colored water in a back and forth motion as the puddle dries. Rocking the water disrupts the surface tension and creates uneven edges—the desired effect.

3 As the lines begin to emerge, Masterfield controls them by pushing the edges with the heat gun air. By directing the motion the surface pattern is intentionally developed. A rotating circular motion produces a circular pattern. Vertical movements produce vertical lines on the surface. An exciting composition evolves as small areas are developed on the picture surface. Drying each area completely prevents unexpected mixing of colors and merging of shapes. Occasionally, color will thicken too much, bubble, and cause an undesirable pattern. In this case, Masterfield adds a small amount of water to redilute the pigments and continues the heat-drying process.

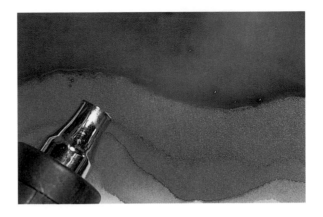

4 She continues rocking the colored water back and forth, varying the intensity of the lines. Allowing the pigment to rest in place while the heat gun dries more water, intensifies lines. Pushing pigment quickly prevents the formation of lines. To build variety, more colors or water may be introduced at any step of the heat-drying process.

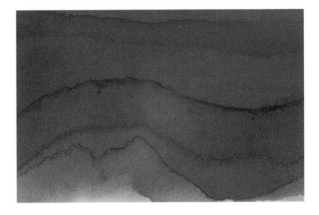

5 Occasionally a small amount of pigmented water remains. By removing this fluid with a tissue, a lighter shade of color is obtained. Allowing water thickly saturated with tint to dry in a puddle, with or without applied heat, creates a shiny, slick area to form on the surface. Such areas are often difficult to amend.

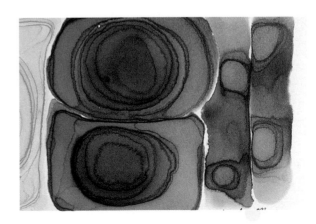

{aGatE

*i*MaG*e*s}

MATERIALS

- Strathmore heavyweight illustration board #500 Series, plate finish
- Inks, watercolors, or acrylics (thinned to a fluid solution)
- Heat gun
- Containers for water
- Flat stones

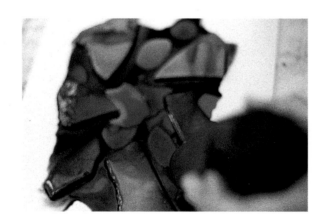

1 Masterfield's heat gun process is further developed by adding flat rocks. The rocks are placed on the Strathmore illustration board surface, and ink is poured around the rocks. The rocks work as a resist. Where they are placed, a halo of color evolves. Some color may also drift under the rock resists. The rock is not moved until the painting is complete. Drying begins.

2 Drying the puddles of color with a heat gun, Masterfield develops individual areas of color. The colors are mixed and added in varying proportions to build excitement. To build more intense layers of color, areas may be rewet and reworked.

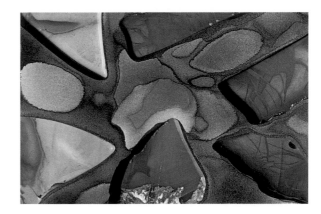

3 When all areas are complete and the desired design is achieved, the rocks are removed. Notice how the color and pattern, which crept under the rock resists, varies. The types of rocks (for example sandstone versus slate) and surface features of rocks influence the resulting pattern. Collect a variety and experiment.

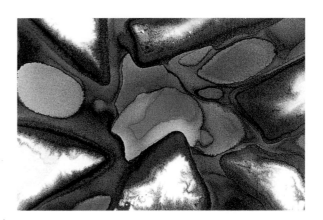

[arTisT's porTfoLio]

"In the early 1970s, I became intrigued with imitating nature. Although I occasionally use the brush, I depend more on unusual tools and materials to achieve a natural image."

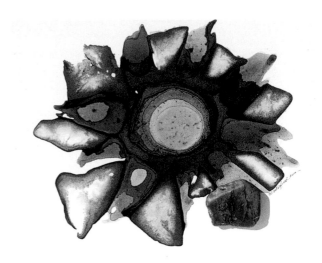

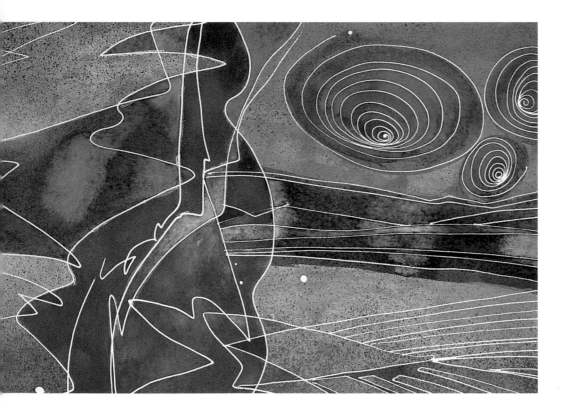

(top) *Surface*
22" x 30" (55.9cm x 76.2cm)
Technique: Heat-dried ink

(left) *Desert Cactus*
22" x 30" (55.9cm x 76.2cm)
Technique: Wax resist and poured paint

(top right) *Morning Mist*
22" x 30" (55.9cm x 76.2cm)
Technique: Wax resist and poured paint

(bottom right) *The Light Within*
9" x 12" (22.9cm x 30.5cm)
Technique: Heat-dried ink with stone adhered to the surface

(far right) *Motion*
30" x 42" (76.2cm x 106.7cm)
Technique: Direct painting and use of squirt bottles

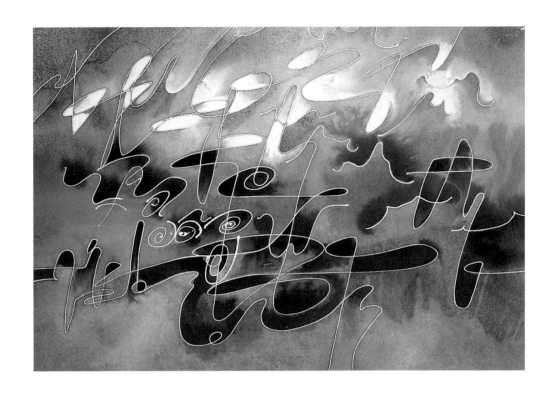

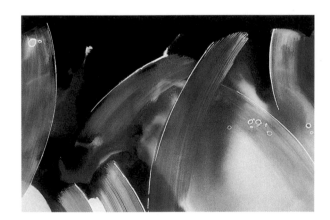

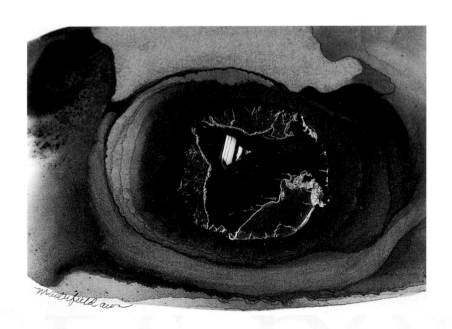

[s h o w c a s e]

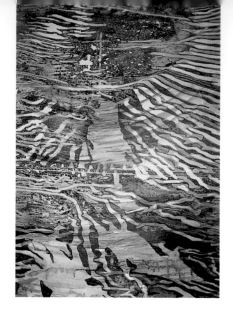

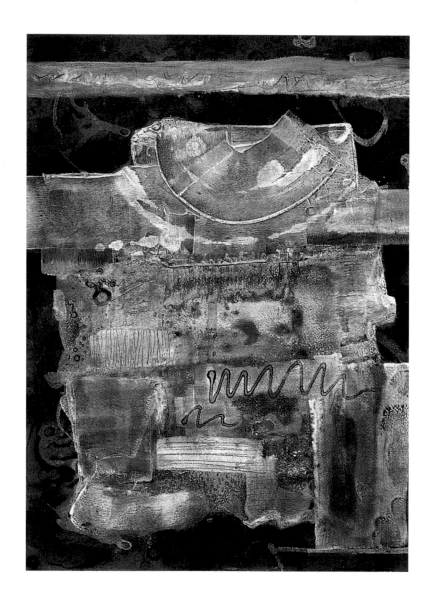

(top) Nancy S. Bush
Ripples on the Pond
30" x 22" (76.2cm x 55.9cm)
Paper: Gatorboard
Technique: Gatorboard primed with gesso, pouring paint on freezer wrap

(left) Marilyn Gross
Ceremonials
30" x 22" (76.2cm x 55.9cm)
Paper: Arches 300# rough watercolor paper
Technique: Acrylic glazing, gesso from squeeze bottle, brayer

(top right) Gayle Denington-Anderson
Convolithic
30" x 45" (76.2cm x 114.3cm)
Paper: Arches 140# rough watercolor paper
Technique: Transparent watercolor washes with gold metallics, watercolor pencil, pouring

(far right) Gayle Denington-Anderson
Great Jade Temple of the Golden Thistle Pagoda
35" x 27.5" (88.9cm x 69.9cm)
Paper: Arches 140# rough watercolor paper
Technique: Watercolor, metallic powder, direct painting, pouring

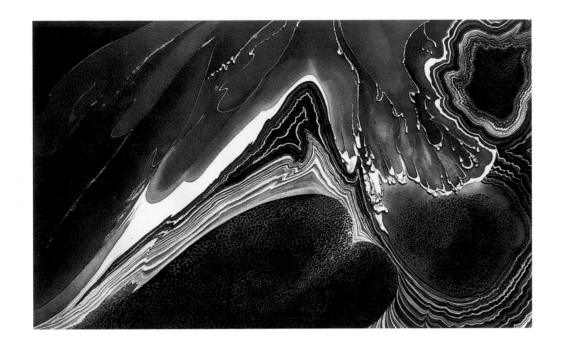

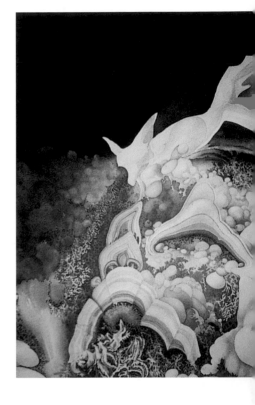

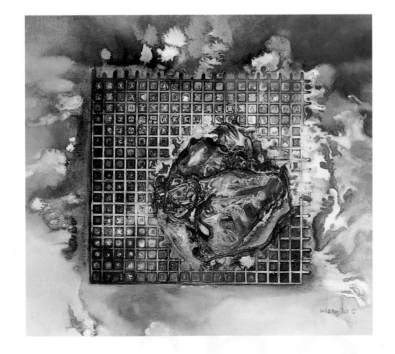

(left) Lula Nestor
Queen's Delight
20" x 20" (50.8cm x 50.8cm)
Fabriano 140# hot press watercolor paper
Technique: Watermedia and chemical reactions, grid
dropped into poured pigment and chemicals

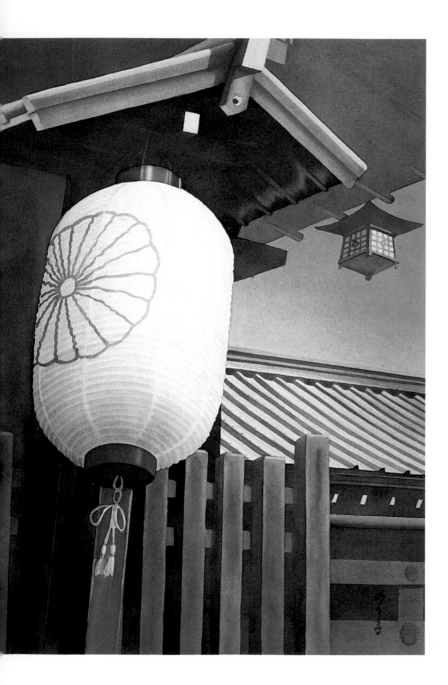

(top) Glenda VanRaalte
Morning Glory
24" x 33" (61cm x 83.8cm)
Paper: Mulberry oriental paper
Technique: Mulberry paper, batik, wax, masking, paint

(left) Noriko Hasegawa
Lanterns
30" x 22" (76.2cm x 55.9cm)
Paper: Waterford 300# cold press watercolor paper
Technique: Pouring, flowing color

(top right) Noriko Hasegawa
Morning Light
22" x 30" (55.9cm x 76.2cm)
Paper: Waterford 300# cold press watercolor paper
Technique: Pouring, flowing color

(right) Sheila T. Grodsky
Flores del Sol
22" x 30" (55.9cm x 76.2cm)
Paper: Lanaquarelle 140# cold press watercolor paper
Technique: Direct painting, negative painting, pouring, using eyedropper
for paint application

(far right) Nedra Tornay
Hanging Fuchsias II
30" x 42" (76.2cm x 106.7cm)
Paper: Arches 555# rough watercolor paper
Technique: Glazing, lifting, texturing with plastic wrap, direct painting

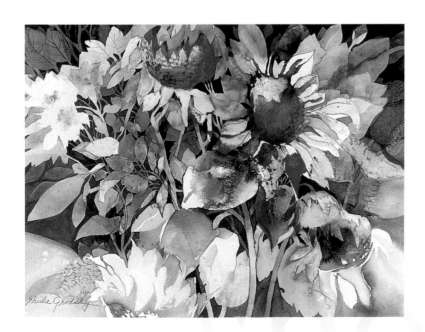

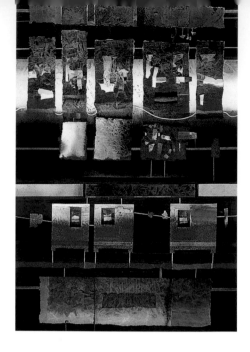

(right) Marianne K. Brown
Tied Up Two
40" x 25" (101.6cm x 63.5cm)
Paper: Arches 260# cold press watercolor paper
Technique: Masking tape, plastic wrap for texture, glazing, lifting

(bottom) Shirley E. Nachtrieb
Red Movement
16" x 20" (40.6cm x 50.8cm)
Paper: Illustration board
Technique: Gesso-sized board, plastic wrap on wet paint then dried and
removed, layering, whites, alcohol

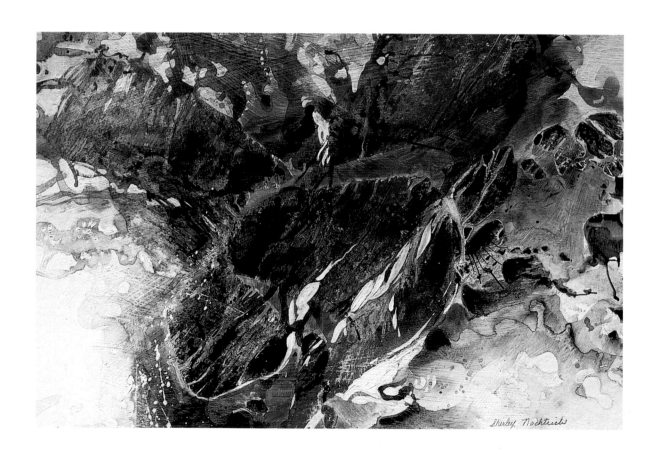

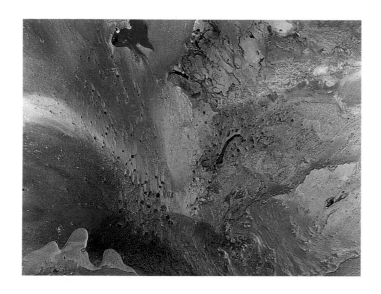

(left) Pat Strickler
Nature's Symphony Movement #1
40" x 50" (101.6cm x 127cm)
Paper: Canvas
Technique: Bronzing powders, ink, layering, pouring

(bottom left) Elise Morenon
Forbidden Forest
30" x 22" (76.2cm x 55.9cm)
Paper: Arches 140# hot press watercolor paper
Technique: Pouring paint, lifting, glazing detail

(bottom right) Bruce G. Johnson
Walk in the Woods
19" x 28.5" (48.3cm x 72.4cm)
Paper: Crescent cold press watercolor board
Technique: Wax crayons, watercolor crayons, glazing

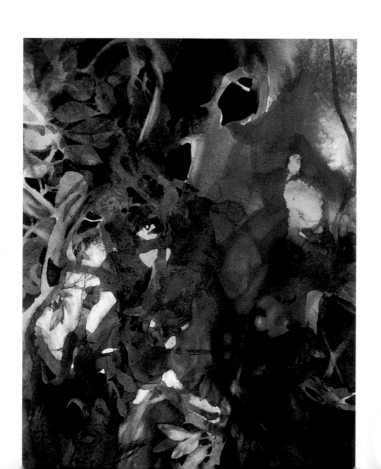

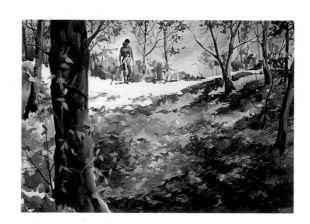

Although she has attended workshops and paints regularly with other
painters, Marlene A. Boonstra is primarily self-taught. Since 1992, she
has been teaching classes at Trinity Christian College and workshops
at the Peninsula Art League. She attained signature status in
the American Watercolor Society.

"Sunlight patterns allow me to incorporate areas of pure white paper and dark colorful shadows. To make shadows interesting I flow intense colors—warm and cool—together in a wet area at a strong angle."

-Marlene A. Boonstra

[into the shadows]

"Compared to planning, drawing, and preparation, painting often seems to take little time and effort." Boonstra considers the subject secondary to the composition and is drawn to patterns of light and shadow. She uses dynamic compositions to create paintings where the shadows are often more important than the objects that cast them. When the flow of paint can not be controlled in a given shadow area, she masks the area to paint a single, strong, unified shadow area. The projects that follow demonstrate how she captures the magic of sunlight and the rich color of crisp shadows in her paintings.

techniques

[and have put away childish things]

MATERIALS
- Crescent #114 cold press watercolor board
- Pebeo masking fluid
- Pigments: Winsor & Newton: Ultramarine Blue, Alizarin Crimson, Winsor Red, Winsor Blue, Winsor Green, Aureolin Yellow, New Gamboge; Holbein: Olive and Cobalt Blue Tint; Rembrandt: Transparent Red, Brown, and Yellow; DaVinci: Cobalt Violet
- Lanaquarelle 1-inch flat
- #10 round brush

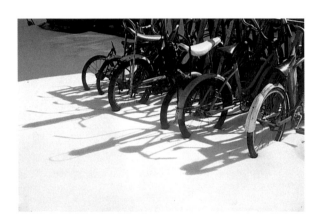

1 Boonstra uses her camera to capture the references for her paintings. Shadows are elusive and she will often take many photos of a scene to obtain the perfect composition. She seeks light, shadow, color, and pattern arrangements to develop in her work. This mid-winter scene of bikes for sale intrigued Boonstra when she first saw it. She returned late in the day to capture the strong diagonal shadows cast by the bicycles.

2 Boonstra relies on strong drawings to begin her work. She draws directly on the Crescent watercolor board in great detail, indicating shadow areas and color changes on surface areas. She next applies the masking fluid to maintain white sunlight areas on the finished painting. She determines a single wash of color is needed for the shadow areas. Masking is essential to obtain this large simplified expanse of shadow. Applying a single wash for all of the shadows will unify the resulting painting.

3 When the masking fluid is completely dried, Boonstra wets the shadow area twice with a sponge to ensure an evenly wet surface area before applying the first wash of color. French Ultramarine Blue, Rembrandt Transparent Brown, and Yellow are applied to the wet shadow area. To control the flow of paint, the first wash is done with the painting in an upside-down position at a very steep angle with the excess water and pigment flowing off the top right corner of the painting. Excess pigment is mopped up as it runs off the painting without ever touching the painting surface.

4 Boonstra waits 24 hours for a completely dry painting surface with clean, crisp edges. The mask is removed from the surface and the direct painting of the bicycles and rack begins. She paints each bike into the bike next to it: This creates a visual unity between the objects. She uses colors with only enough water for them to flow in a downward stream, alternating colors often to encourage color changes within each object. When she gets to the bottom she goes back to the top and begins the process again until the objects are complete.

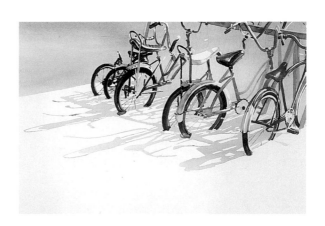

5 Using water and a stiff bristle brush, Boonstra lifts out soft highlights. For visual impact, spots of bright color are added throughout the bicycle shapes. A vibrant neutral gray includes Winsor Blue, Winsor Green, and Alizarin Crimson. This combination punctuates small areas on the far side of the bike rack.

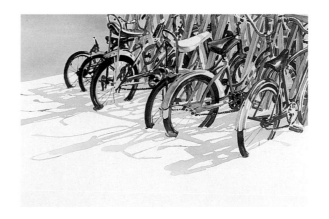

[artist's portfolio]

"Like a fine ballet, a good painting has a spontaneous quality to it."

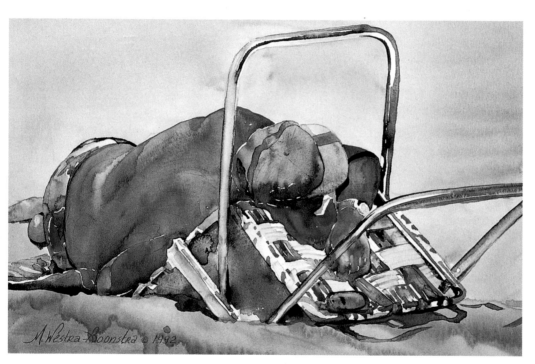

(top) **Supportive Role**
19" x 29" (48.3cm x 73.7cm)
Technique: Washes used as a unifying element

(top right) **9/10 of the Law**
19" x 29" (48.3cm x 73.7cm)
Technique: Washes used as a unifying element

(bottom right) **Put to Pasture**
9.5" x 19" (24.1cm x 48.3cm)
Technique: Washes used as a unifying element

(far right) **Sunwashed**
9.5" x 19" (24.1cm x 48.3cm)
Technique: Washes used as a unifying element

(top) **A Place in the Sun**
10" x 15" (25.4cm x 38.1cm)
Technique: Washes used as a unifying element

(right) **No Strings Attached**
28" x 18.5" (71.1cm x 47cm)
Technique: Washes used as a unifying element

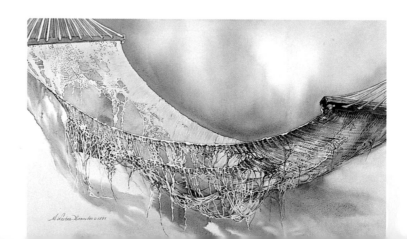

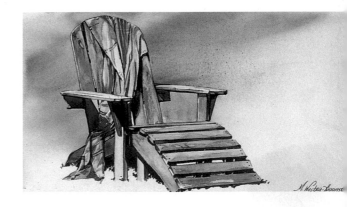

[s h o w c a s e]

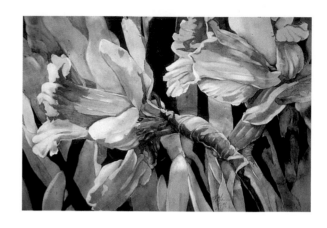

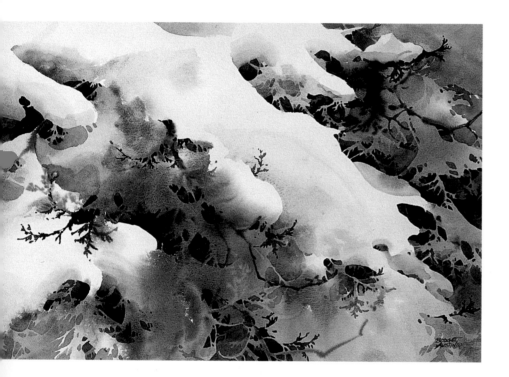

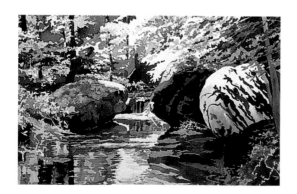

(top) Patricia Ritter
Daffodils III
22" x 30" (55.9cm x 76.2cm)
Paper: Arches 140# cold press watercolor paper
Technique: Direct painting, wet-on-wet, negative painting

(left) Bridget Austin
Fallen Snow
21" x 29" (53.3cm x 73.7cm)
Paper: Lanaquarelle 300# cold press watercolor paper
Technique: Loose washes, flowing color, positive and negative painting

(bottom) Mary Ann Pope
The Dismals
8.5" x 13" (21.6cm x 33.0cm)
Paper: Lanaquarelle 140# cold press watercolor paper
Technique: Wet-on-wet, direct painting, masking

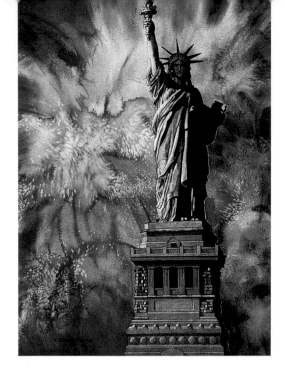

(*left*) Marilyn Edmonds
Sweet Liberty
30" x 32" (76.2cm x 81.3cm)
Paper: Arches 300# cold press watercolor paper
Technique: Watercolor wash, salt, fluid masking,
direct painting

(*bottom*) Joyce Grace
Odyssey Tondo
23" x 35" (58.4cm x 88.9cm)
Paper: Arches 300# cold press watercolor paper
Technique: Direct painting, wet-on-wet

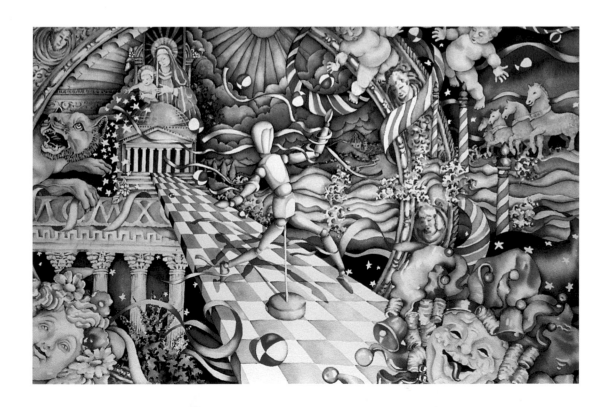

(left) Carl Vosburgh Miller
Sagging Lights
22" x 30" (55.9cm x 76.2cm)
Paper: Arches 140# cold press watercolor paper
Technique: Loose washes, direct painting, flowing color

(bottom) Virginia Blackstock
Wheels, Wheels, Wheels
28" x 36" (71.1cm x 91.4cm)
Paper: Arches 140# cold press watercolor paper
Technique: Wet-on-wet, direct painting, flowing color

(top right) Carlton Plummer
Sunlite Pine
30" x 20" (76.2cm x 50.8cm)
Paper: Strathmore illustration board
Technique: Wet-on-wet, glazing

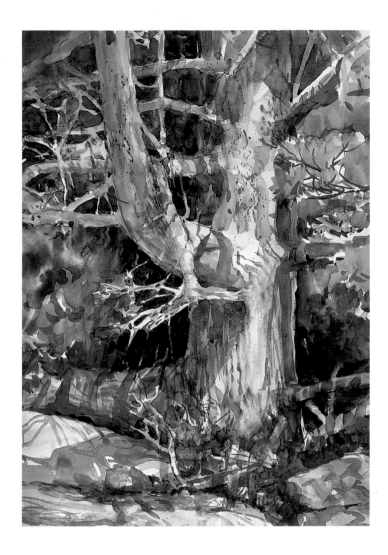

(right) Kim Seng Ong
Heart of Kathmandu
22" x 30" (55.9cm x 76.2cm)
Paper: Arches 300# rough watercolor paper
Technique: Watercolor, direct painting, flowing color, mixing color on paper surface

(bottom) Joyce Williams
A Wheel Within
30" x 40" (76.2cm x 101.6cm)
Paper: Arches 300# cold press watercolor paper
Technique: Limited palette, direct painting, wet-on-wet, flowing color

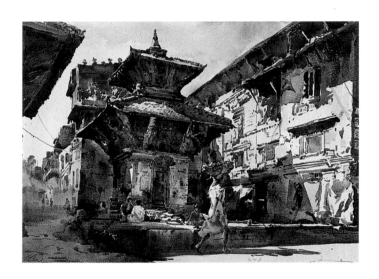

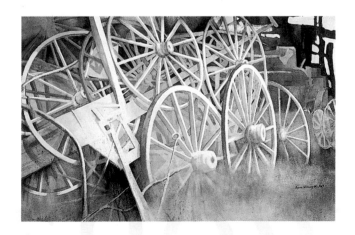

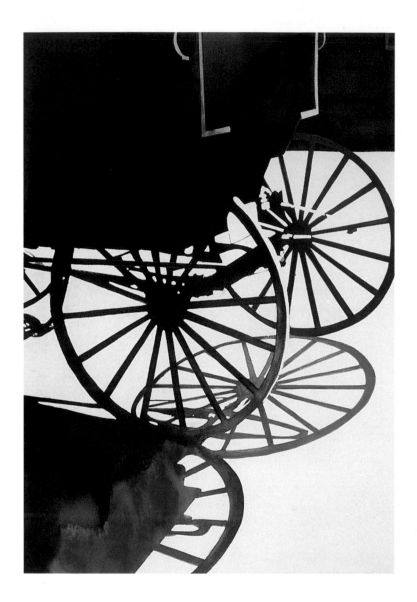

(top) Marietta Petrini
Coming to America
25" x 19" (63.5cm x 48.3cm)
Paper: Fabriano 140# cold press watercolor paper
Technique: Wet-on-wet, direct painting

(left) Jane Higgins
Buggy Wheels
30" x 22" (76.2cm x 55.9cm)
Paper: Arches 140# cold press watercolor paper
Technique: Liquid mask, poured color

(bottom) Margaret Graham Kranking
Sunlit Zinnias
22" x 30" (55.9cm x 76.2cm)
Paper: Arches 140# cold press watercolor paper
Technique: Strong lights and darks, masking, glazing, wet-on-wet

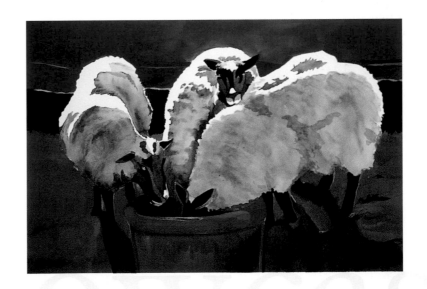

(top) Michael Schlicting
Life's Choices
22" x 30" (55.9cm x 76.2cm)
Paper: Arches 300# cold press watercolor paper
Technique: Liquid mask, washes, glazing, direct painting

(right) Wendy Mattson
Beyond the Garden
31" x 44" (78.7cm x 111.8cm)
Paper: Arches 300# cold press watercolor paper
Technique: Wet paper, saturated color, flowing color, lifting, scrubbing

(bottom) Colleen Newport Stevens
Sheepfeast II
22" x 30" (55.9cm x 76.2cm)
Paper: Lana Aquarelle 300# rough watercolor paper
Technique: Paint mixing on a vertical surface, watercolor crayon, ink, flowing color

(top right) Mei Shu
East of Venice
22" x 30" (55.9cm x 76.2cm)
Paper: 90# Strathmore hot pressed watercolor paper
Technique: Washes of watercolor, blending, flowing color

(far right) Barbara Nechis
Vegetal Forms
15" x 22" (38.1cm x 55.9cm)
Paper: Arches 140# cold press watercolor paper
Technique: Transparent watercolor, wet-on-wet, flowing color

(bottom right) Genie Marshall Wilder
Tia's Tureen
22" x 30" (55.9cm x 76.2cm)
Paper: Lanaquarelle 300# cold press watercolor paper
Technique: Direct painting, wet-on-wet, flowing color

(top) Genie Marshall Wilder
Back to the Real World
15" x 21" (38.1cm x 53.3cm)
Paper: Crescent watercolor board
Technique: Wet-on-wet, flowing color

(left) Jane Bertram Miluski
Circles
21" x 29" (53.3cm x 73.7cm)
Paper: Arches 140# cold press watercolor paper
Technique: Liquid mask, direct painting, lifting

(bottom) Tom Francesconi
Spectator
21" x 14" (53.3cm x 35.6cm)
Paper: Arches 140# cold press watercolor paper
Technique: Large white areas, negative shapes, flowing color

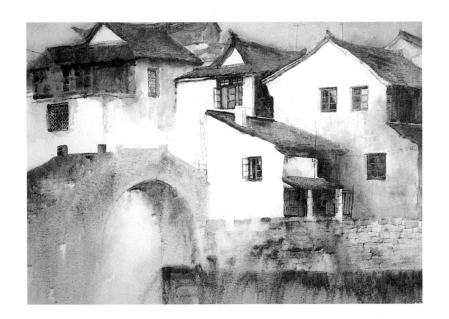

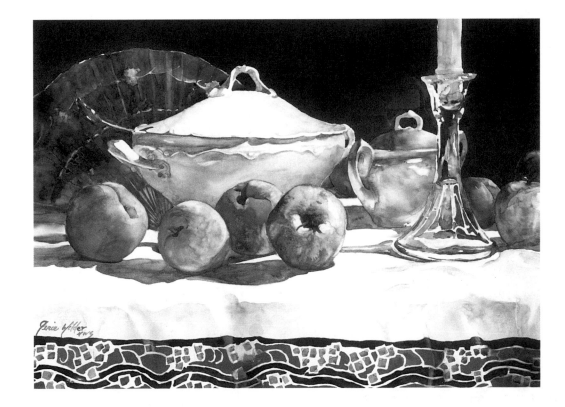

[section two: techniques inspired by materials]

Watercolor crayons, intense inks, bright watercolor pencils, fluid, liquid acrylics, slick hot-surfaced papers, rough-textured watercolor boards—these materials are often the catalyst for an artist to begin a work or to try a special effect. The artists in the following chapters delight in the use of these constantly evolving materials.

materials

Mary Ann Beckwith is an Assistant Professor in the Fine Arts
Department of Michigan Technological University where she teaches drawing,
design, and watercolor painting. She has also taught numerous workshops,
served as juror in a variety of shows, and served as the president
of the Midwest Watercolor Society.

"The intense, saturated colors I use are not part of my environment or of places I have been. They are from a part of my soul. I feel a very strong need to fill my world with great, outrageous fields of color."

-Mary Ann Beckwith

[caught in the web]

"The images which I create reflect the evolution of my vision." Design is a conscious element within Beckwith's work. Washes of white paint build rhythmic patterns on the surface and enhance her design. She uses layers, sometimes as many as ten to fifteen, of colored washes, as well as applications of colored pencil and pastel. She varies her watermedia techniques with each new painting—from the application of traditional transparent washes to the use of webbing and spraying ink.

[o r i g i n s :
r e v e l a t i o n]

MATERIALS

- Arches 140# hot press watercolor paper
- Creepy Cobwebs—threaded dacron cobwebs used for Halloween decoration
- Lightfast inks (including white)
- White gouache paint
- Transparent watercolors
- Natural and geometric cutouts for painting resists
- Watercolor pencils
- Gatorboard
- Spray bottles for the inks
- Windex
- Pushpins

1 Beckwith begins by attaching two sheets of watercolor paper to a piece of gatorboard with push pins. Creepy Cobwebs are stretched tautly over the surface and attached with push pins. The surface and webbing are sprayed with water and any excess water is poured off. Working quickly, Beckwith sprays lightfast inks onto the paper and cobwebs. The colors flow along the webs to create a rich variety of colors. During the painting process, she gently rewets and presses any cobwebs that lift from the watercolor surface.

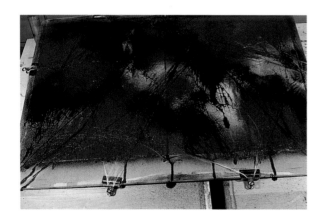

2 Beckwith sprays additional layers of ink on the wet painting. She carefully mops large pools of ink off the painting, while smaller pools are left on the surface and encouraged to run by tilting the gatorboard. The paint courses along the strands of webbing intensifying the color where the webbing touches the surface and causing further color mixing.

3 The painting dries just until the sheen has left most of the surface. Lifting the webbing gently, Beckwith is careful not to disturb the lines that are still wet. She applies colored ink with a brush to tone any white portions of the paper. Beckwith moves the painting to a clean surface before it dries completely, so that it does not adhere to the gatorboard.

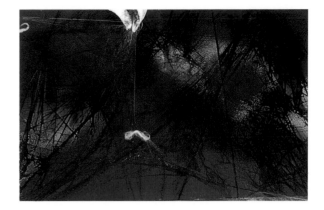

4 Beckwith lays out resists in a variety of shapes. She sprays diluted white ink, varying the density of coverage, removes the resist, and allows the painting to dry. Selected edges are softened by lifting the white ink with Windex, an excellent solvent for the white ink. Small shapes are lifted out of the white as well. Using white gouache, watercolor pencils, and diluted white gouache, Beckwith develops movement and color transitions.

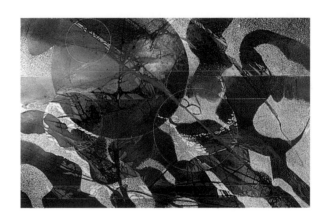

5 After re-evaluating the painting, Beckwith decides to unify the painting by lifting the white to create larger shapes of color. With watercolor pencils, Beckwith builds transitions that separate each geometric shape from its surroundings. (See page 66 for finished painting.)

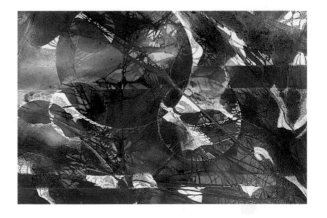

[ORIGINS: celebration]

MATERIALS

- Arches 140# hot press watercolor paper
- Creepy Cobwebs—threaded dacron cobwebs used for Halloween decorations
- Lightfast inks (including white)
- Transparent watercolors
- Watercolor pencils
- Natural and geometric cutouts for painting resists
- White gouache paint
- Spray bottles for the inks
- Gatorboard
- Windex
- Pushpins

1 Again Beckwith begins by spreading the Creepy Cobwebs across watercolor paper. The surface and webbing are sprayed with water, and lightfast inks are then sprayed onto both the paper and cobwebs. Beckwith again develops the circle images and enhances alternating bands of very light- to medium-intensity white layers. Each band has some intensity variation to prevent the flattening of depth that comes with even application of white. In some areas, for example to the left of the largest circle, she makes the transition between shapes invisible. The white layers are allowed to dry.

2 To develop flowing shapes Beckwith paints diluted white gouache in varying shapes that together create flowing forms. The strong diagonal forms create a contrast and tension with the bars.

3 Intense color in the two largest circles is developed with watercolor pencil using a variety of shapes. While some color transitions are subtle, others are quite stark. She extends the color forms out of the largest circle and into the band to maintain the lost edge. For opposition, a fine blue line pierces the large red form in the large circle.

4 Beckwith continues adding contrast through color layering. More flowing color forms are built, while fine contrasting red lines are used to break the blue shapes in the largest circle. Red is also added to the lower right circle to unify it with the rest of the painting.

5 The white shapes below the upper right circle are further refined to enhance the illusion of entrapped spheres. White flowing shapes are used to create greater unity in the four layers in the upper left corner. In the lower left, the white shapes are extended to create more interesting negative space. Color development is completed with minute details, such as the final red touches in the lower left portion of the largest circle.

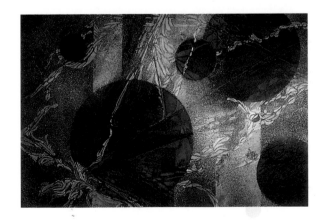

[aⅡtist's poⅡtfoLio]

*"Each day of painting is a new challenge. New
methods, new visions, new ideas inspire me to
interpret the world around me."*

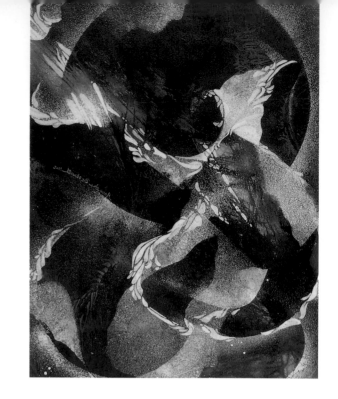

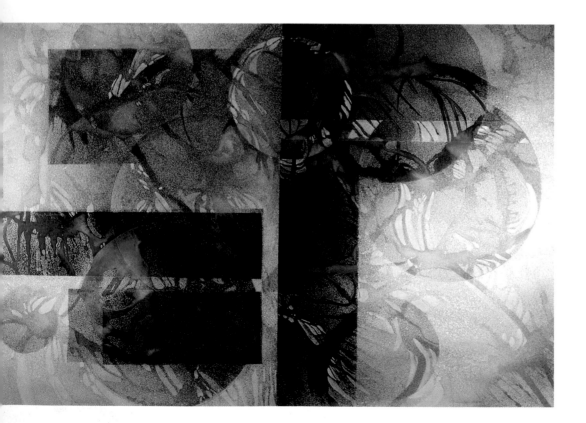

(left) Origins: A Tension
40" x 60" (101.6cm x 152.4cm)
Technique: Texture, spray painting, direct painting,
and watercolor pencils

(top) Origins: Flight
30" x 22" (76.2cm x 55.9cm)
Technique: Texture, spray painting, direct painting,
and watercolor pencils

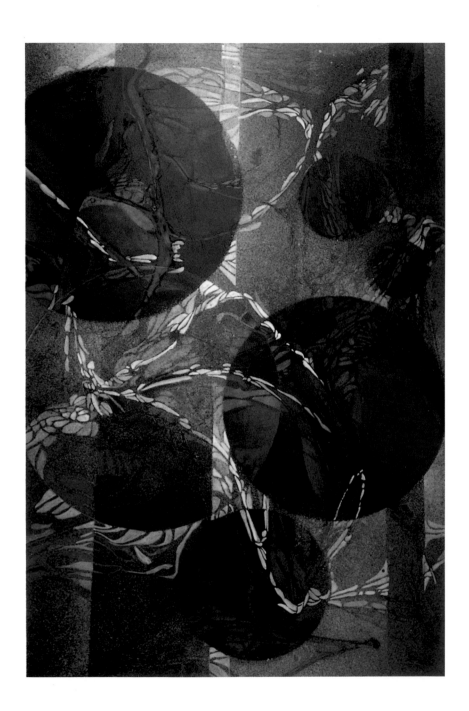

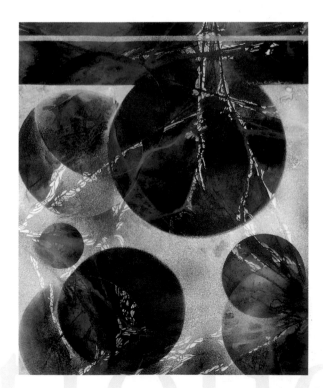

(left) **Origins: Surrender**
22" x 30" (55.9cm x 76.2cm)
Technique: Texture, spray painting, direct painting, and watercolor pencils

(bottom) **Origins: Celestial Prophesy**
40" x 60" (101.6cm x 152.4cm)
Technique: Texture, spray painting, direct painting, and watercolor pencils

[s h o w c a s e]

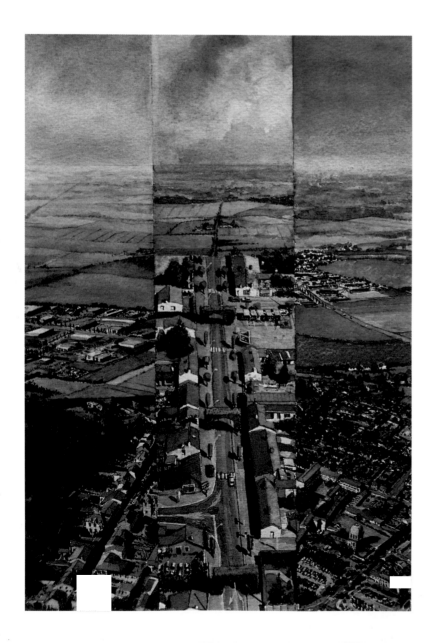

(top) Carrie Burns Brown
Southwest Motif #2
22" x 30" (55.9cm x 76.2cm)
Paper: Morilla paper
Technique: Watermedia, collage, layering, lifting

(left) Dominique Yves Agnellet
Lucon
11" x 8.66" (27.9cm x 22.0cm)
Paper: Canson 140# Montval watercolor paper
Technique: Painting within a painting, direct painting, layering, razor blade

(top right) Marilynn Derwenskus
West Meets East: Differently
30" x 22" (76.2cm x 55.9cm)
Paper: Fabriano 300# cold press watercolor paper
Technique: Direct painting, glazing

(far right) Al Brouillette
Dimensions VIII
30" x 22" (76.2cm x 55.9cm)
Paper: Strathmore 500# illustration board
Technique: Layering, glazing

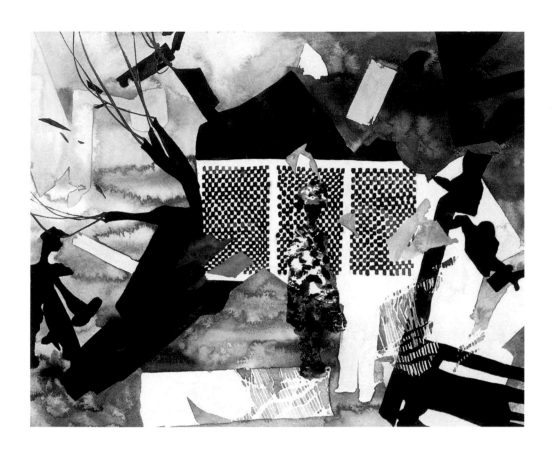

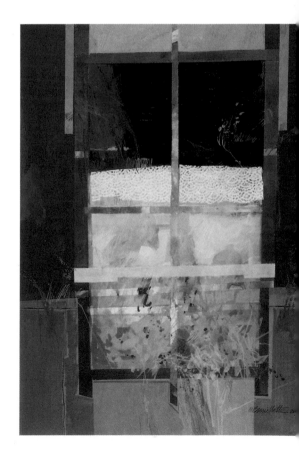

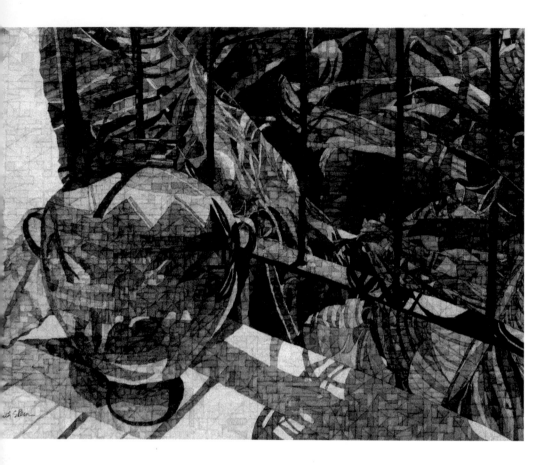

(left) Judith S. Rein
Balcony Scene
10" x 14" (25.4cm x 35.6cm)
Paper: BFK Rives lightweight watercolor paper
Technique: Direct painting, geometric shapes, grid

(bottom) R. G. Millman
Fragments d'Architecture Antique
28" x 20" (71.1cm x 50.8cm)
Paper: Arches 140# cold press watercolor paper
Technique: Liquid watercolor dripped onto wet paper, glazing, strong design elements

(top right) Fredi Taddecci
Superior's Frenzy
29" x 21.5" (73.7cm x 54.6cm)
Paper: Arches 140# cold press watercolor paper
Technique: Watermedia gouache, acrylic layering, prismacolor pencil

(far right) Incha Lee
Deep in the Woods
22" x 30" (55.9cm x 76.2cm)
Paper: Arches 140# hot press watercolor paper
Technique: Halloween webbing, spraying inks

(bottom right) Dominique Yves Agnellet
Jardin's Secrets
10.5" x 13" (26.7cm x 33cm)
Paper: Canson 140# Montval watercolor paper
Technique: Painting within a painting, watercolor, gouache, layering, strong design elements

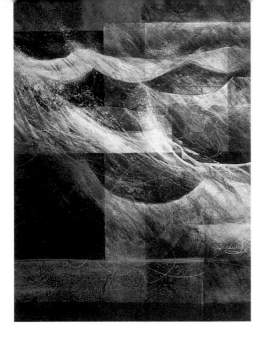

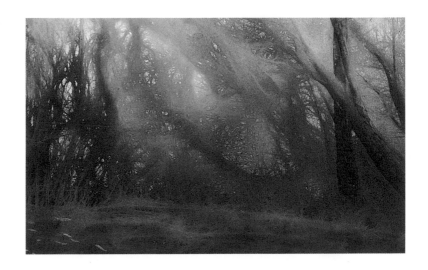

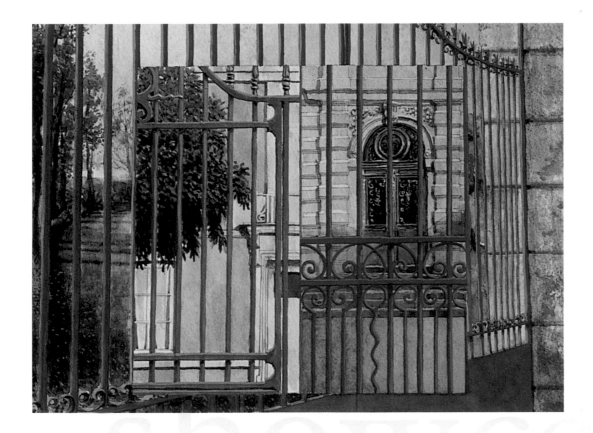

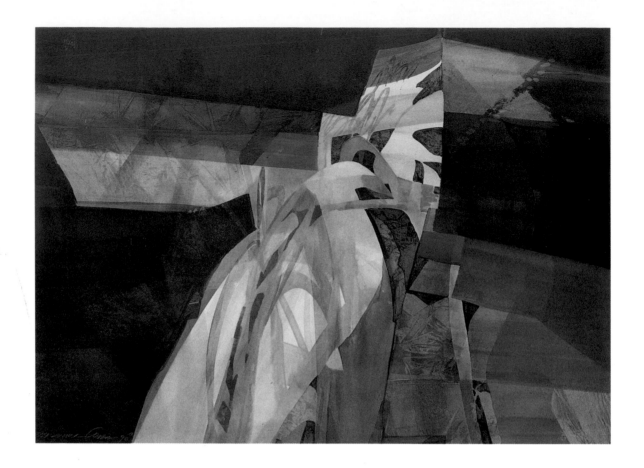

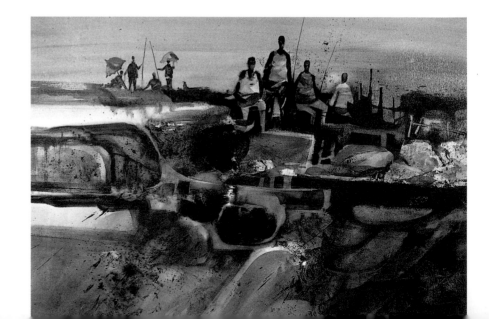

(top left) Virginia Cobb
Untitled II
32" x 40" (81.3cm x 101.6cm)
Technique: Layering, lifting, glazing

(far left) Carol Lynn Pohl
Devil's Advocate
14" x 10" (35.6cm x 25.4cm)
Paper: Arches 300# cold press watercolor paper
Technique: Ink dropped to surface, sprayed downward, liquid mask

(bottom left) Jorge Bowenforbes
UITVLUGT
30" x 40" (76.2cm x 101.6cm)
Paper: Strathmore cold press illustration board
Technique: Soaking, scrubbing out color, lifting

(top) Virginia Cobb
Untitled I
32"x 40" (81.3cm x 101.6cm)
Technique: Direct painting, layering, lifting, acrylic glazing

(bottom right) Maureen Nolen
Solace
32.5" x 28.5" (82.6cm x 72.4cm)
Paper: Photographic paper
Technique: Photo paper, layering of inks, plastic shapes laying in ink
for images

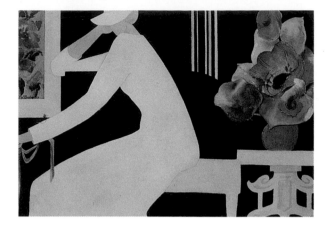

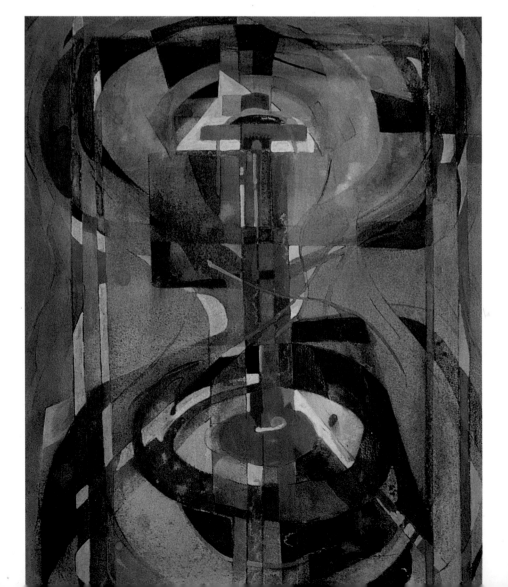

(top) Al Brouillette
Horizons III
20" x 18" (50.8cm x 45.7cm)
Paper: Strathmore 500# illustration board
Technique: Layering, glazing, lifting

(right) Dorothy Watkeys Barberis
White Patterns
21" x 29" (53.3cm x 73.7cm)
Paper: Arches 300# cold press watercolor paper
Technique: Flat watercolor application, direct painting,
strong design elements

(bottom) Sybil Moschetti
Variations on Figure Eight
42" x 30" (106.7cm x 76.2cm)
Paper: Arches 300# rough watercolor paper
Technique: Fluid mask, watercolor wash, layering

(top) M. E. Procknow
Eyes That Will Not See
24" x 18.75" (61cm x 47.6cm)
Paper: Crescent illustration board
Technique: Watercolor with acrylic medium, interference colors, layering, direct painting

(right) Edith Marshall
Midnight Watching
30" x 22" (76.2cm x 55.9cm)
Paper: Morilla 140# paper
Technique: Spraying inks, layering, gauze texture, metallic ink

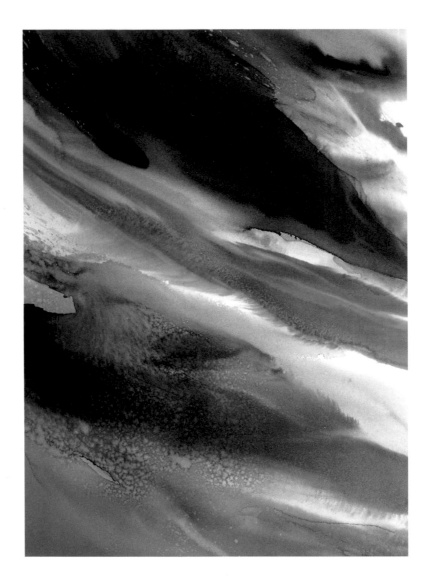

Don Carmichael is a studio artist and a dedicated teacher. He worked
in the pigment industry as a color stylist and is co-founder and
past president of the Tennessee Watercolor Society. Since 1964, Don has
taught workshops, given lectures and demonstrations, and taught at Union
University, University of Tennessee, and Eastern Illinois University.

"Although technique and craftsmanship are important, I depend on the spontaneity that watermedia affords. I create textures using many methods such as: spraying water into a wet wash, blotting a wet area with a non-absorbing paper, and leaving a mottled effect or monoprint on the surface."

-Don Carmichael

[k e e p i n g i t m o v i n g]

"The movement and flow of the wet surface is the most exciting part of painting." Almost all watermedia artists experience a rush when vibrant colors flow across a painting surface. The pulse and flow of color moving on the surface energize the artist. Carmichael uses a wetting agent to increase the flow of pigment and capture the energy of running water, and a thickening agent to create acrylic-like texture while maintaining the transparency and solubility of the watercolor. His process is one approach to pushing watercolor past traditional limits.

[o N t b E b A y]

MATERIALS

- Strathmore hot press illustration board
- Robert Doak liquefied watercolors: Sepia, Transparent Red Oxide, Raw Sienna, Indigo Blue, Cobalt Blue, Graphite (gray), Ivory Black
- Carboxy-methyl cellulose (thickening agent)
- 1-inch, 2-inch, and 3-inch brushes; #2, #6, and #12 round; #2 and #6 fan bristle
- Ox gall solution: 5-6 drops ox gall to one quart water
- Painting knife
- Natural silk sponge
- Drafting tape
- Reflector lamp
- Squeeze bottle for each color
- Tissues and paper towels
- Spray bottle (for the ox gall solution)

1 First Carmichael tapes a border on the illustration board with 1-inch drafting tape. This prevents the edge of the board from becoming saturated. He wets the surface evenly with a water and ox gall solution with a spray bottle and 3-inch brush to encourage the pigment to move on the paper's surface. Starting at the upper left hand corner, Carmichael squeezes liberal amounts of Indigo Blue and Raw Sienna from bottles which mix on the paper surface. He tilts the board to encourage the pigments to blend and mix on the surface.

2 He repeats the process to intensify the color and increase the directional development of the sky. This procedure may be done several times if desired, only after each wash is completely dried. Other colors can be added to succeeding washes.

3 Carmichael adds a ridge of sea grass to the composition using a #2 round brush and a mixture of carboxy-methyl cellulose, Cobalt Blue pigment, and Sepia pigment. Carboxy-methyl cellulose is a thickening agent which gives depth and texture similar to acrylic gels. Unlike the acrylic gels, when it is rewet it redissolves and can be manipulated on the surface. Carmichael uses a palette knife to scrape in the grassy texture, and a tissue in the middle left area to lift out the rock shapes. A wash of Transparent Red Oxide and Raw Sienna is added with a 2-inch flat brush. He sprays the water solution again to increase the flow of this wash.

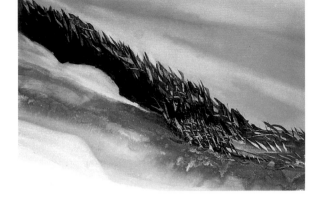

4 For color harmony and balance, Carmichael reintroduces the same colors in the foreground used in the previous stages. He applies Sepia, Raw Sienna, and Red Oxide, with the addition of Ivory Black and Graphite (gray), to the foreground to depict beach debris. He splatters pigment with a brush and palette knife. He then spatters water using the same technique to create a varied texture.

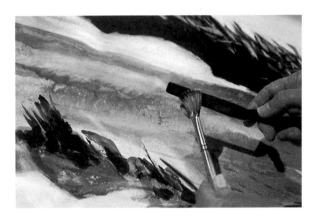

5 Carmichael now removes the drafting tape and evaluates the painting. The background is gently refined, using a chisel-shaped vinyl or typing eraser to lift out some fine sea grass forms against the sky. He uses a wet sponge to refine the rock shape and texture, and reviews the painting for final touches.

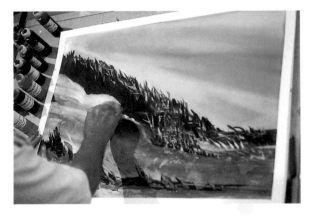

[arTist's porTfolio]

*"I seldom use reference material...I adhere to
the philosophy that those images remembered are
the important images, those you should be
expressing in your painting."*

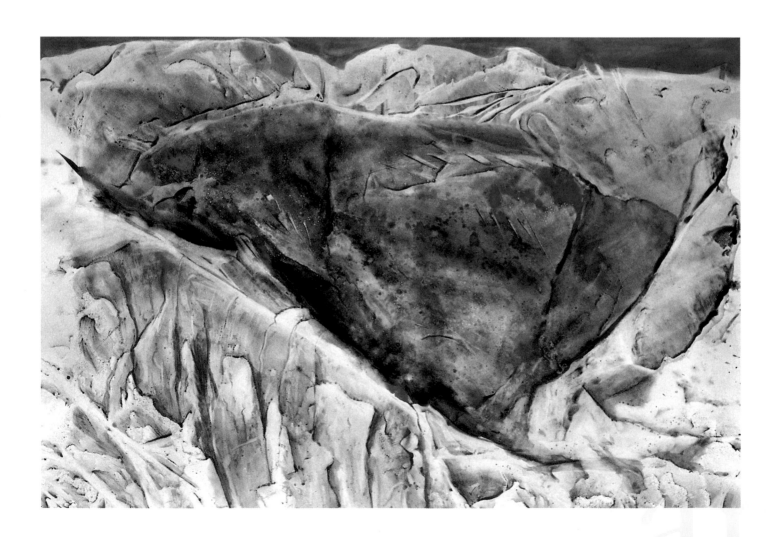

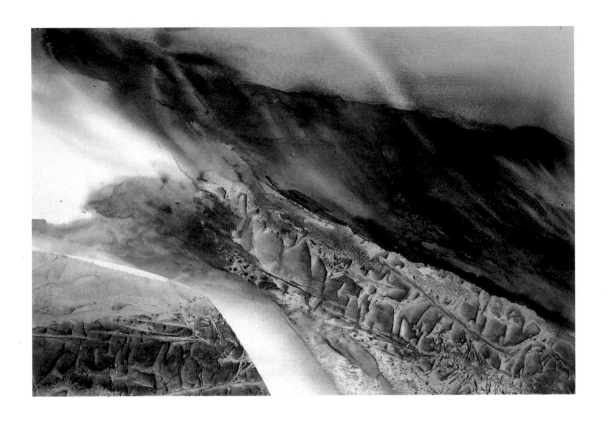

(top left) **Crashing Wave II**
40" x 30" (101.6cm x 76.2cm)
Technique: Use of spray, ox gall, and carboxy-methyl cellulose for texture

(top) **Glacier, Mt. Baker WA**
30" x 40" (76.2cm x 101.6cm)
Technique: Use of spray, ox gall, and carboxy-methyl cellulose for texture

(right) **Sea Rock III**
25" x 35" (63.5cm x 88.cm)
Technique: Use of spray, ox gall, and carboxy-methyl cellulose for texture

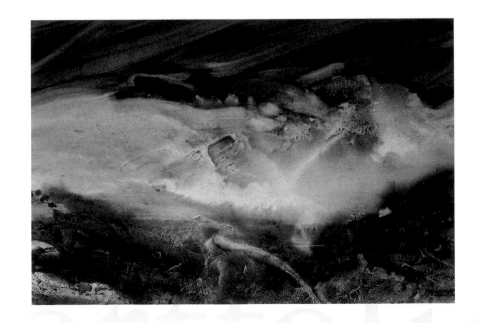

[s h o w c a s e]

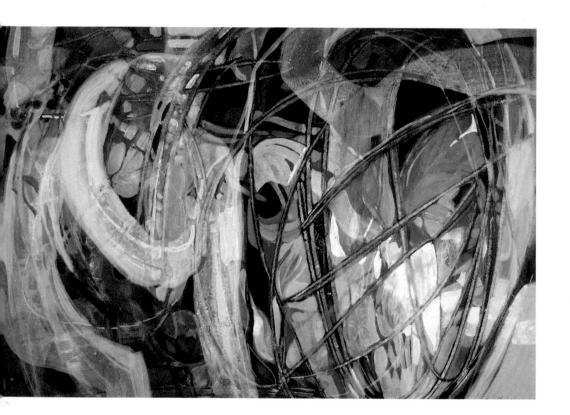

(top) Carmen Newman Bammert
His House, My House
18" x 15" (45.7cm x 38.1cm)
Paper: Crescent 100# cold press illustration board
Technique: Acrylic gel sizing for texture, masking, layers of acrylic

(left) Patsy Smith
Optical Seranade
28.5" x 36.5" (72.4cm x 92.7cm)
Paper: Aquarius watercolor paper
Technique: Treated surface, splashing, scraping, direct painting, matte medium

(top right) Terry Wickart
Baptism
20" x 30" (50.8cm x 76.2cm)
Paper: Strathmore cold press watercolor board
Technique: Casein, acrylic, colored pencil, lifting or scraping

(far right) Tony J. Warren
Maple Knot
24" x 40" (61cm x 101.6cm)
Paper: Untempered Masonite, primed
Technique: Gesso-treated masonite, acrylic medium to simulate: oils, egg tempra, casein, gouache, watercolor

(bottom right) Joseph Melancon
Flag and Trumpet
30" x 22" (76.2cm x 55.9cm)
Paper: Lanaquarelle 140# cold press watercolor paper
Technique: Splattering for texture, direct painting

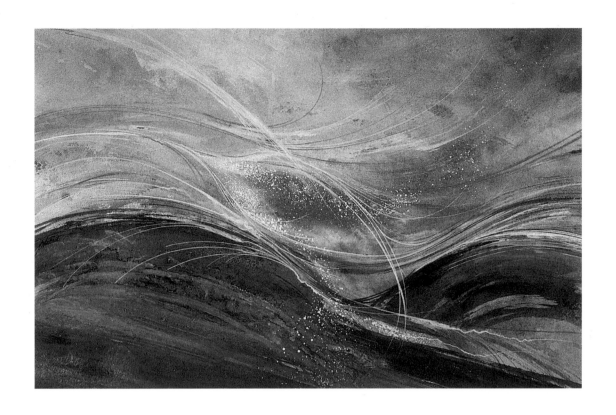

(top) Kay Dawson
Our Gang
9.5" x 14" (24.1cm x 35.6cm)
Paper: Lanaquarelle 300# cold press watercolor paper
Technique: Direct painting, grid painting for rug texture

(left) Pauline Eaton
Winged Cosmic Rose
30" x 40" (76.2cm x 101.6cm)
Paper: #110 Crescent illustration board
Technique: Watercolor heavily applied on illustration board, lifted, scrubbed and scraped

(top right) Bill James
The Green Mask
30" x 26" (76.2cm x 66.1cm)
Paper: Illustration board
Technique: Gesso-treated surface, glazing

(far right) Marianne K. Brown
Sunday Morning Airview-Flight 334
38" x 25" (96.5cm x 63.5cm)
Paper: Arches 260# cold press watercolor paper
Technique: Mask, washes, salt, scraping, lifting

(bottom right) Jeannie Grisham
American Accoutrements VI
23" x 30" (58.4cm x 76.2cm)
Paper: Indian Bagasse
Technique: Jute and sugar cane fiber, gesso, Conte pastel, watermedia, scraping, spattering, use of wire brush for texture

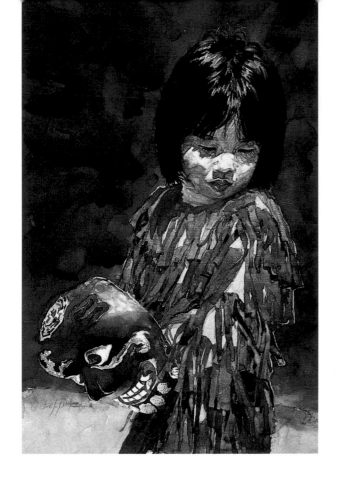

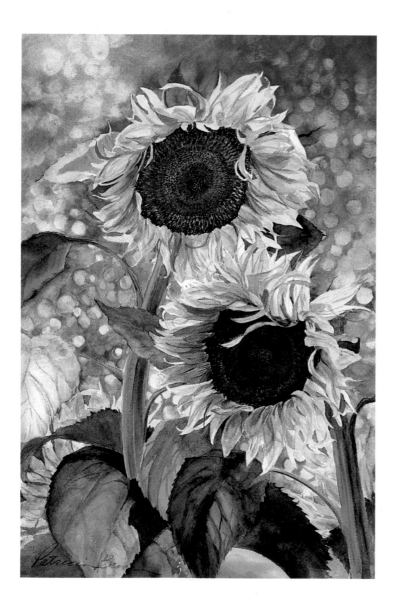

(top) Robert Nolin
Small World
11" x 19" (27.9cm x 48.3cm)
Paper: Arches 90# hot press watercolor paper
Technique: Texture and color alteration for design

(left) Patricia Bason
Sunspots
22" x 15" (55.9cm x 38.1cm)
Paper: Arches 300# cold press watercolor paper
Technique: Direct painting, lifting, glazing

(top right) Robert Nolin
Guardian Angel
12" x 9" (30.5cm x 22.9cm)
Paper: Arches 90# hot press watercolor paper
Technique: Brush work for texture

(far right) Elise Morenon
Shadows
22" x 30" (76.2cm x 76.2cm)
Paper: Arches 140# hot press watercolor paper
Technique: Loose washes, watercolor and charcoal drawing, gesso

(bottom right) Judith S. Rein
Railyard Blues
11" x 17" (27.9cm x 43.2cm)
Paper: Torinoko printing paper
Technique: Painted directly with small random shapes on grid for texture

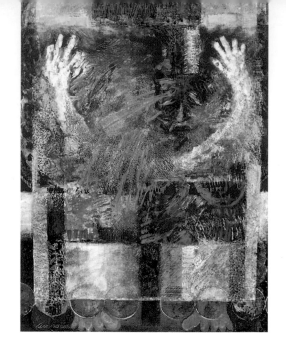

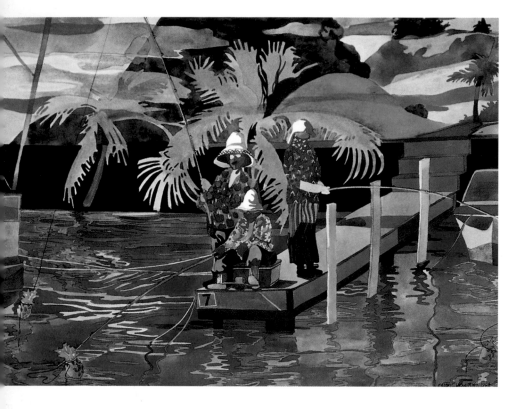

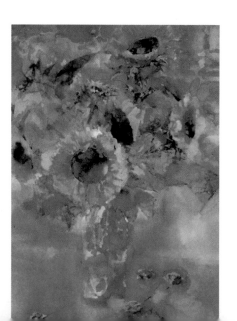

(top) Barbara Leites
Anguish III
30" x 22" (76.2cm x 55.9cm)
Paper: Strathmore Excalibur watercolor paper
Technique: Glazing, layers of texture

(left) Melanie Lacki
Lanai Ladies
22" x 30" (55.9cm x 76.2cm)
Paper: Arches 140# cold press watercolor paper
Technique: Hot press paper, ox gall fluid wash, direct painting

(bottom) Alex Koronatov
Autumn Delights
28" x 20" (71.1cm x 50.8cm)
Paper: Arches 140# cold press watercolor paper
Technique: Watermedia, direct painting, lifting to create texture

(top right) Bill James
Church in the Gables
21" x 17" (53.3cm x 43.2cm)
Paper: Illustration board
Technique: Gesso-treated surface, glazing

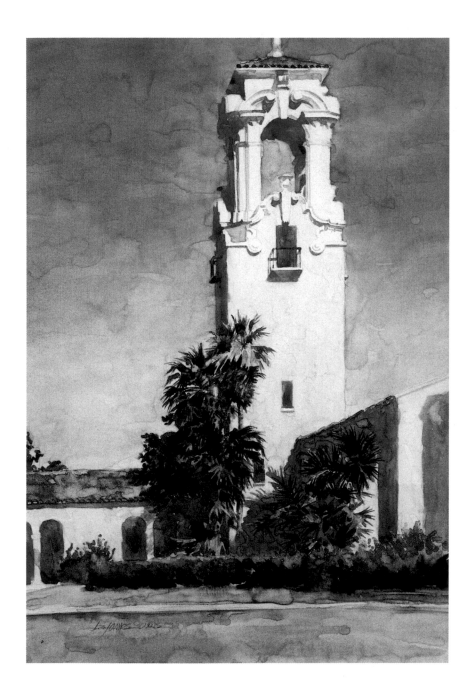

(bottom right) Barbara J. Hranilovich
Testing the Waters
9" x 12" (22.9cm x 30.5cm)
Paper: Arches 140# hot press watercolor paper
Technique: Orange gouache paint, blue-grey over paint,
pencil for texture, lifting

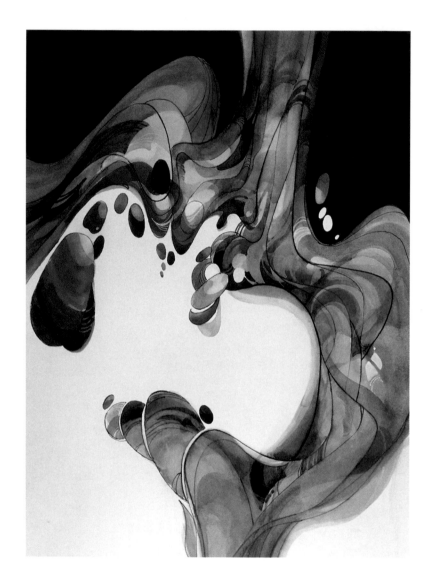

Edward Minchin was born and educated in Essex, England, and received
his B.A. from St. Martin's Art School in London. He is a member of The
American Watercolor Society, the Midwest Watercolor Society, and Audubon
Artists, Inc.. Minchin has been the recipient of more than 60 awards
throughout the United States and abroad.

"Apart from the sheer joy of playfully pushing paint around on paper, canvas, metal, plexiglass, or any other surface, creating incredible color combinations and unexpected shapes, painting is very much akin to solving major problems in one's life."

-Edward Minchin

{ the best laid plans... }

"**B**arriers must be overcome to gain freedom of expression and allow the painting to lead in its own direction." Every artist encounters the challenge of artist's block, but Edward Minchin approaches his work with the valuable lessons acquired during thirty years as a professional graphic designer. To overcome these blocks, Minchin recommends a positive successful attitude and a planned approach to your work with sketches or value studies. He sees the "chaos or mud" stage as a stepping stone, not a millstone, and finds experimentation and spontaneity afford creativity. His semi-abstract works employ strong design and inventive color use.

{ *l i q u i d*

f e e l i n g }

MATERIALS

- Arches 140# Hot Press watercolor paper
- Pigments: Windsor Newton tube watercolors: Permanent Violet, Windsor Blue, Lemon Yellow, Cadmium Orange, Cerulean Blue, Opera. Also in palette: Peacock, Red Sienna, Yellow Ocher, Windsor Orange, Windsor Green, Alizarin Crimson, Rose Madder Genuine, Windsor Red. • Sponge
- Rotring inks: Blue Turquoise, Red • Reducing glass
- 6B soft pencil • Rapidograph white and black pens

1 Before filling the water containers or touching a brush to the painting, Minchin first establishes a positive attitude. He firmly believes his attitude is as important as the actual painting process. Minchin often works from a 2 x 3-inch spontaneous thumbnail sketch which he transfers to a 15 x 22-inch sheet of Arches 140# hot press paper. His sketch establishes the large, simple areas and the grouped areas of planned detail in his work.

2 Minchin determines the work will have a cool dominance with some small underlying areas of warm color. Using the pencil lines as guides, he applies transparent washes of color. Although he is working from a pre-established design, Minchin paints loosely and freely to keep the spontaneous feeling in his work. Colors flow and mix on the surface to increase the variety of hues being used.

3 The darkest area is quickly established by blocking in the top sections with a mixture of Permanent Violet and Windsor Blue. At this stage, Minchin is seeking an immediate color contrast. He paints the small ovals, being careful to vary the color and value in each. Next, he uses a black permanent fine point pen to give definition to some of the flowing pencil lines.

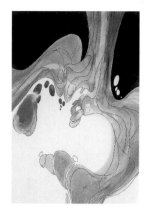

4 Minchin glazes in darker washes while focusing on retaining cool and warm areas. Shapes are defined within shapes by glazing layers of color in specific areas. The ink lines become more prominent as flowing color shapes are added which run counter to the lines. For example, the blue-green swirl in the top of the yellow-orange area on the right does not follow the sketched contour lines. This uninhibited layering adds spontaneity and excitement to the work.

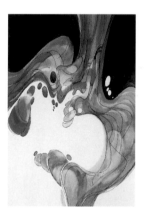

5 Minchin glazes over the large dark area once again to build stronger contrast. He develops more detail by layering more intense color and building some spots of bright pure color. The separated ovals are painted with bands of color to unify them with the large form. Finally, Minchin intensifies spots of color and specific areas by additional glazing. He lifts some color with a sponge and clean water to define several of the light areas. Using a reducing glass to view the painting, Minchin can eliminate fine detail to see the entire painting. He uses a wash of white acrylic paint to remove the detail in the lower right portion and to simplify the image. (See page 96 for finished painting.)

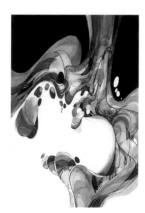

[*fa*LL*e*n l*e*Av*e*s]

MATERIALS
- Surface—a discarded painting
- Assorted acrylic colors and white acrylic paint. Select colors which harmonize with the discarded painting you have chosen.

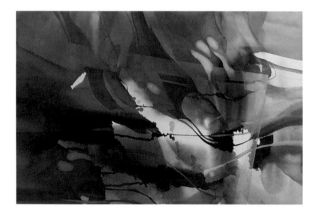

1 Turning the rejected painting upside-down to break down any pre-existing influences, Minchin begins to work on the new piece. This start has strong diagonal and horizontal color bands to consider. Minchin selects paint colors which are compatible with his painting's surface. Painting warm colors into warm and cool colors into cool, he begins to add layers of color to the surface.

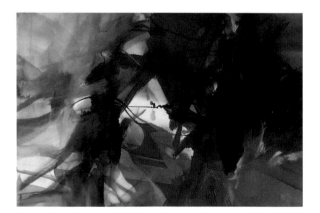

2 Minchin applies rich dense acrylic colors and works them into the surface and glazes the painting with white to build contrast and to better define the design. He adds more color. Most strokes are still bold, but a few (upper left corner) are more delicate.

3 Minchin now builds relationships between the shapes and establishes the large shape which flows through the painting. He also paints in several additional white shapes. Basic patterns, such as the rich brown rectangular forms in the upper right, are repeated. Repeated shapes are another means of indicating motion and adding unity to the image.

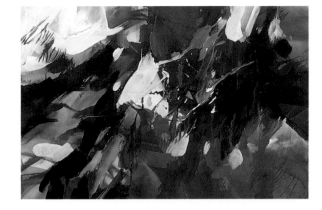

4 At this point, Minchin decides to make some color changes. He flows a watered-down blue-green over the yellow, to unify this area with the left side of the painting, and refigures the red glaze at the top and repeats the rich brown rectangles. Applying finishing touches and some bright glazes of Peacock Blue (Holbein paint) over some of the dark and white areas, Minchin creates a cool dark and some spots of very bright blue. This also shifts the hue and value in the lower right corner.

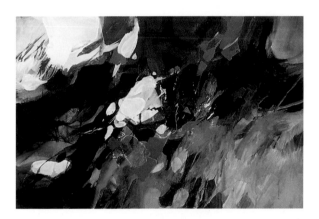

5 To soften some areas, Minchin glazes over the right side of the painting with a translucent layer of white. This accentuates the dark shapes and defines some edges within the painting. The result is somewhat similar to looking through a brightly reflecting window pane. The shapes and colors behind the sunlight reflections, on the right, are more subtle, while those behind the shaded glass, on the left, are crisp and clear.

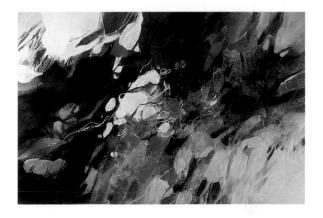

[artist's portfolio]

"There is no end to the search for new methods, materials, and experimentation, which, fortunately, keeps thought open to ever-expanding forms of expression. And this is the life force that gives light to inspiration."

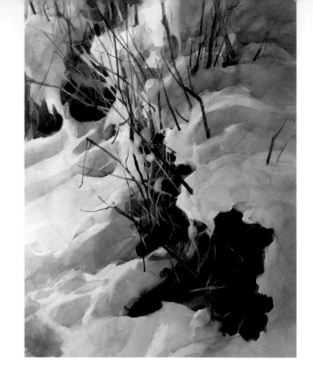

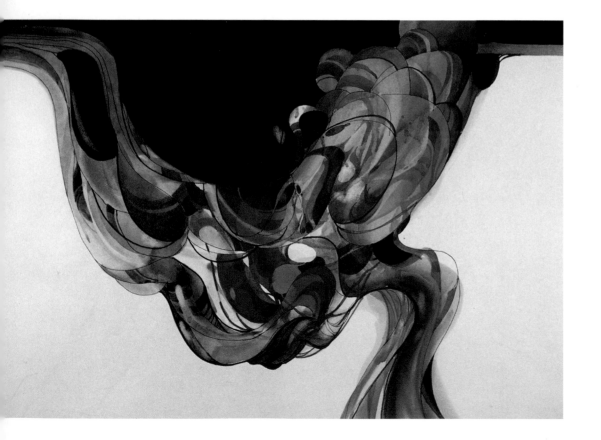

(left) **Chemical Color**
15" x 21" (38.1cm x 53.3cm)
Technique: Glazing, Rapidograph pens

(top) **Snow Secrets**
28.5" x 21.5" (54.6cm x 183.9cm)
Technique: Wet-on-wet, direct painting

(top right) **Lava Flow**
15" x 21" (38.1cm x 53.3cm)
Technique: Wet-on-wet, direct painting

(right) **Trapped**
28.5" x 21" (72.4cm x 53.3cm)
Technique: Wet-on-wet, direct painting

(far right) **Rocky Shore**
21.5" x 28.5" (54.6cm x 72.4cm)
Technique: Wet-on-wet, direct painting

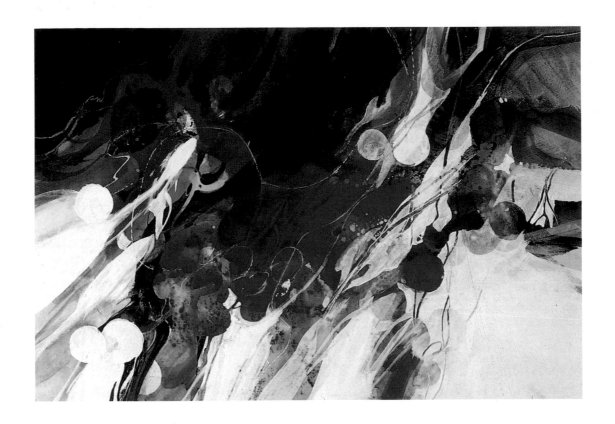

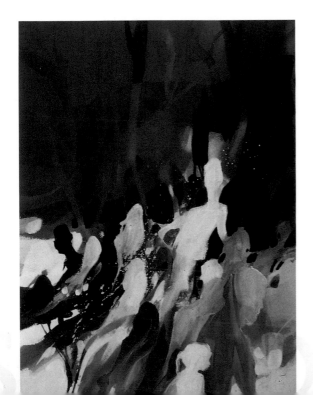

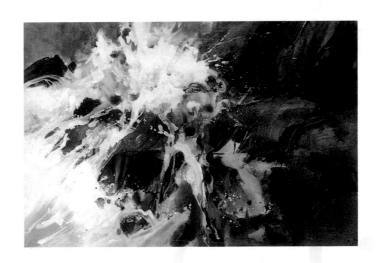

[s h o w c a s e]

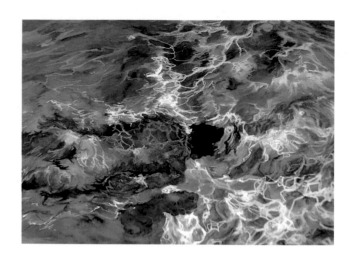

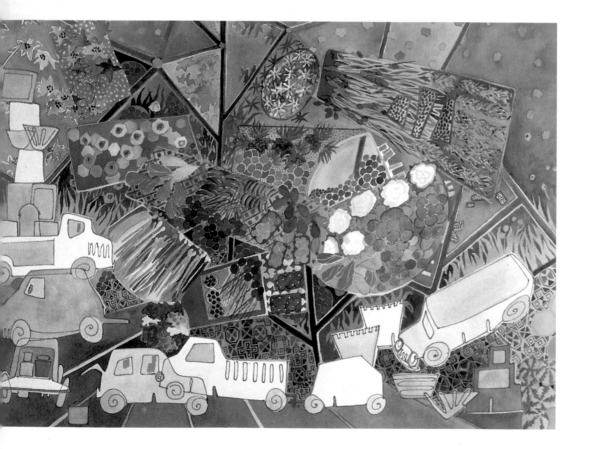

(top) Ken Landon Buck
Alternating Currents
35" x 46" (88.9cm x 116.9cm)
Paper: Crescent board
Technique: Gouache, layering, watercolor crayons

(left) Patricia Bratnober
To Market To Market
36" x 46" (91.4cm x 116.9cm)
Paper: Arches 300# watercolor paper
Technique: Permanent marking pen ink, watercolor

(top right) Valerie Moker
She's Looking Back at Me
20" x 22" (50.8cm x 55.9cm)
Paper: Arches 300# cold press watercolor paper
Technique: Negative painting, glazing, layering,
sandpaper

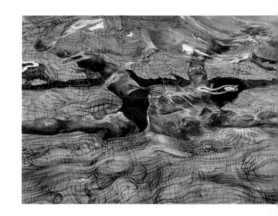

(far right) Ken Landon Buck
Crosscurrents
25" x 34" (63.5cm x 86.4cm)
Paper: Crescent board
Technique: Glazing, layering, watercolor crayons

(bottom) Barbara St. Denis
Kaleidoscopic View III
15" x 22" (38.cm x 55.9cm)
Paper: Arches 140# cold press watercolor paper
Technique: Partially pretreated surface, flicked with mat
medium, glazing

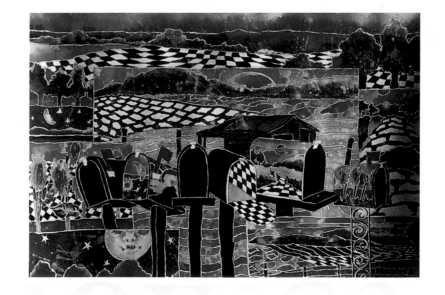

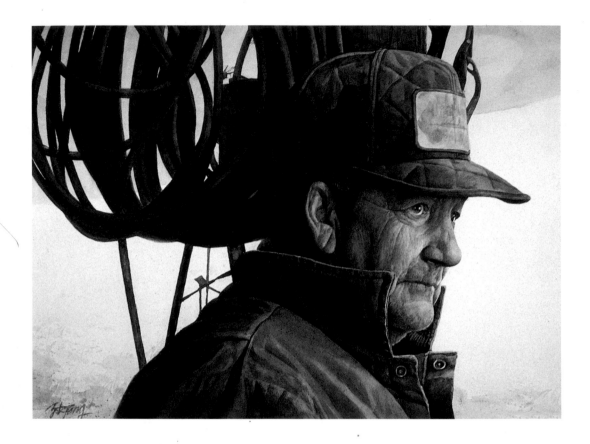

(top) Z.L. Feng
Miles to Go
20" x 24" (50.8cm x 70.0cm)
Paper: Arches 140# hot pressed watercolor paper
Technique: Layering, glazing, direct painting

(right) Yumiko Ichikawa
Still Life With Imari Plates #1
22" x 30" (55.9cm x 76.2cm)
Paper: Strathmore 80# cold press watercolor paper
Technique: Direct painting, glazing

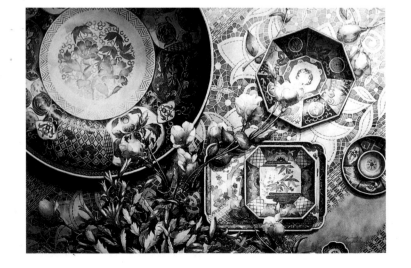

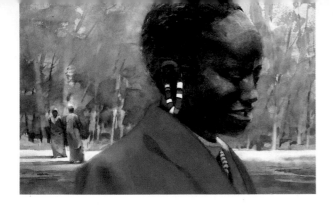

(top) George W. Delaney
The Elders
22" x 30" (55.9cm x 76.2cm)
Paper: Arches 140# cold press watercolor paper
Technique: Direct painting, glazing

(right) Sam Knecht
Amelia's Quilt
30" x 22" (76.2cm x 55.9cm)
Paper: Winsor Newton 300# cold press watercolor paper
Technique: Direct painting, glazing, lifting

(bottom) Yumiko Ichikawa
Still Life with Imari Plates #2
30" x 22" (76.2cm x 55.9cm)
Paper: Arches 140# hot pressed watercolor paper
Technique: Glazing, direct painting

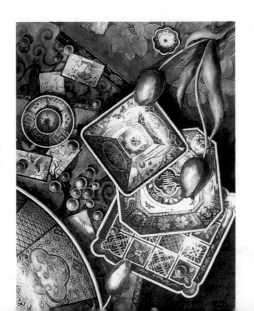

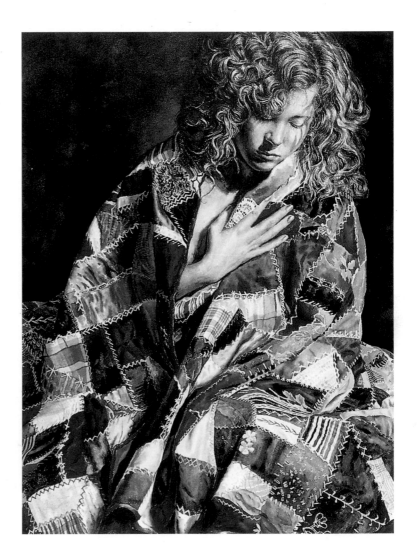

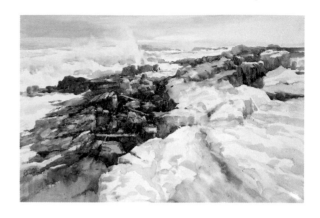

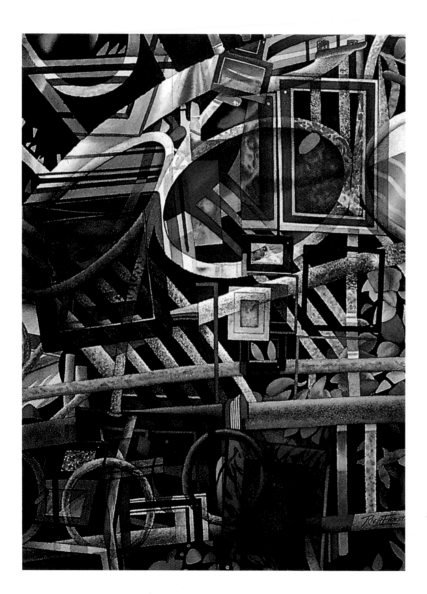

(top) Carlton Plummer
Vanishing Snow
22" x 30" (55.9cm x 76.2cm)
Paper: Strathmore Aquarius II
Technique: Wet-on-wet, direct painting, glazing

(left) Rich Ernsting
Sheer Spectrum
29" x 20" (73.7cm x 50.8cm)
Paper: Arches 300# cold press watercolor paper
Technique: Direct painting, glazing, layering

(top right) Arne Lindmark
Aunt Mamie's Quilt
22" x 30" (55.9cm x 76.2cm)
Paper: Fabriano 140# rough watercolor paper
Technique: Acrylic underpainting, watercolor glazing

(far right) Jane Destro
Alex
28" x 36" (71.1cm x 91.4cm)
Paper: Fabriano Artistico 300# cold press watercolor paper
Technique: Direct painting, glazing

(bottom right) Michael Schlicting
Fossil Flight
22" x 30" (55.9cm x 76.2cm)
Paper: Arches 300# cold press watercolor paper
Technique: Fling liquid mask, washes, glazing, direct painting

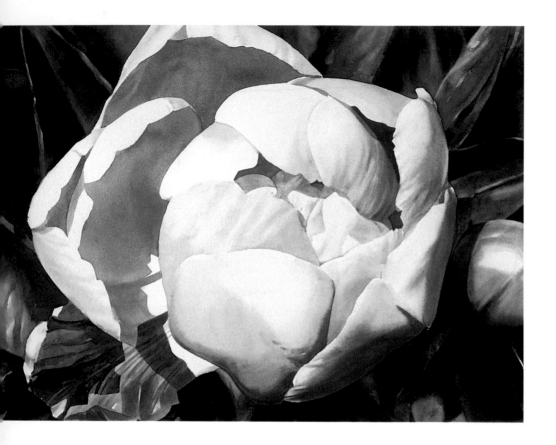

(top) Ann Pember
Piquant Peony
21.5" x 29" (54.6cm x 73.7cm)
Paper: Arches 300# cold press watercolor paper
Technique: Glazing, color mixing on paper surface

(left) Ann Pember
Peony Unfolding
21.5" x 29.5" (54.6cm x 74.9cm)
Paper: Arches 300# cold press watercolor paper
Technique: Painting around lights, glazing

(bottom) Ellen Jean Diederich
Midnight Tapestry
29" x 35" (73.7cm x 88.9cm)
Paper: Arches 140# cold press watercolor paper
Technique: Glazing, masking, lifting paint

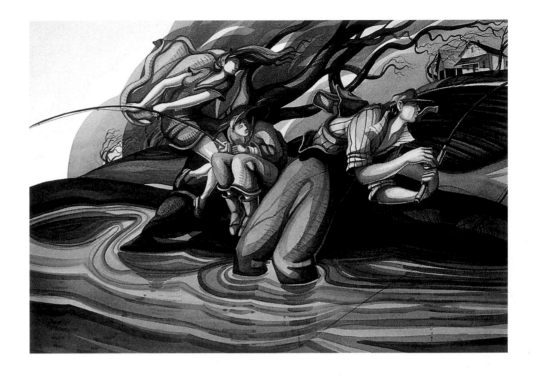

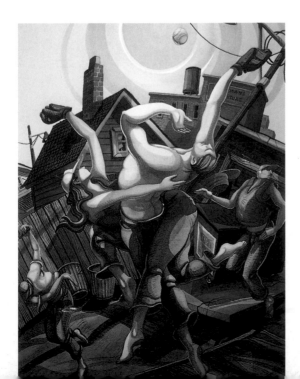

(top left) Anne Bagby
Deja Blue
32" x 21" (81.3cm x 53.3cm)
Paper: Arches 140# cold press watercolor paper
Technique: Glazing, direct painting

(top right) Robert L. Barnum
Hooked
22" x 30" (55.9cm x 76.2cm)
Paper: Arches watercolor paper
Technique: Strong personal view of life, direct painting, glazing

(bottom) Robert L. Barnum
Alley Ball
30" x 22" (76.2cm x 55.9cm)
Paper: Arches watercolor paper
Technique: Direct painting, glazing

(top) Lisa Englander
Cair Paravel
30" x 22" (76.2cm x 55.9cm)
Paper: Arches 400# watercolor paper
Technique: Direct painting, glazing, layering

(left) Chris Krupinski
Three Oranges
22" x 30" (55.9cm x 76.2cm)
Paper: Arches 300# rough watercolor paper
Technique: Direct painting on dry surface, saturated
pigments, glazing

(bottom) Rowena M. Smith
Seraglio #9
22" x 30" (55.9cm x 76.2cm)
Paper: Arches 140# cold press watercolor paper
Technique: Watercolor, water soluble pens, direct
painting, overlapping planes

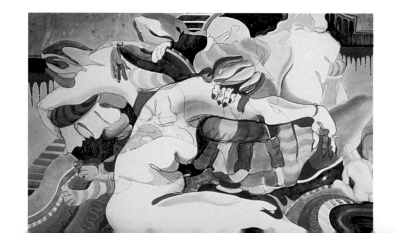

{SECTION THREE: TECHNIQUES INSPIRED BY TECHNOLOGY}

Computers with scanners and laser printers; the Internet and World Wide Web with electronic galleries; immense stores of information and discussion groups; televisions; videos; digital photography cameras; projectors; air brushes...These technologies open vast new frontiers for artists to explore.

For some artists, these technologies free them from old limitations, provide them with a means to instantly investigate unexpected combinations of images, and permit them to explore their own personal visions. Artists in this section create images of their inner worlds, often using technology as a stepping stone.

A signature artist in the American and National Watercolor Societies,
Mark Mehaffey is a teacher and studio artist. His work is regularly
included in national exhibitions, and frequently he is the recipient of
awards such as Dillman's Creators Workshop Award and
the M. Grumbacher Gold Medal Award.

"The spray painting process appeals to my analytical side. The whole process is controlled: from the value sketch, to the working drawing, to cutting and spraying. The creative part is in converting lines to shapes and deciding what to paint in the first place."

-Mark Mehaffey

[old tool- new technique]

"**I** firmly believe that lines are the vehicle and shape is my destination." Subject matter drives Mark Mehaffey's work. His unique technique captures the texture and glow of his subjects. He uses frisket film to define shapes and a mouth atomizer to spray watercolor. With these tools, he builds layers of color and patterns of value. Mehaffey uses this time-consuming process because the large spray droplets allow portions of all of the preceding layers to show through and enhance the watercolor glow. This series of steps reflects only one of the techniques he uses. Mehaffey varies his working styles to best present his subject.

[*t r o p* ι *c a l*
s τ r ɛ e τ s c e n e
3]

MATERIALS

- 140# hot press watercolor paper
- Sketch book
- Watercolors: Ultramarine Blue, Quinacridone Rose, Cadmium Yellow Light, Quinacridone Red, Pthalo Blue, New Gamboge (yellow)
- Baby food jars
- Mouth atomizer
- Frisket film or clear contact paper
- Tracing vellum
- 5B drawing pencil
- Spoon
- #11 X-ACTO knife and several blades
- Electric eraser

1 The artist draws a 4- by 6-inch sketch of a scene, developing the lights and darks. He then stretches a sheet of watercolor paper and staples it to a board. Mehaffey derives a full-scale working drawing and develops it on tracing vellum with a 5B drawing pencil. He presses hard to deposit a heavy layer of graphite on the vellum, and uses an electric eraser to make any corrections. Mehaffey then lays the frisket, sticky side down, on the vellum drawing. He burnishes every line with the bowl of a spoon to pick up as much graphite as possible. The frisket is lifted and applied to the prepared watercolor paper. The lines remain on the frisket and are not transferred to the watercolor paper.

2 Using an X-ACTO knife, Mehaffey cuts the film and lifts away the shapes that will become the darkest darks—the storm grate frame and openings. In this step, Mehaffey sprays most of the grate with multiple layers of Ultramarine Blue, a few layers of Quinacridone Rose, and two layers of Cadmium Yellow Light, bringing the value only to light mid-tone. To add variety, he removes some of the small light shapes showing through the large shadow and sprays them with a layer or two of New Gamboge Yellow. Replace the X-ACTO blades often for best results and precise edges.

step-b

3 Mehaffey develops the shadows by cutting around the smaller areas of light that occur within the larger shadows. He then removes the larger areas of frisket film that cover the darkest shadow to the right of the storm grate. He sprays multiple layers of Ultramarine Blue, Pthalo Blue, Quinacridone Rose, and Cadmium Yellow, making the shadow lighter and warmer as it moves off the paper to the left. He uses more layers of Cadmium Yellow as he works toward the left.

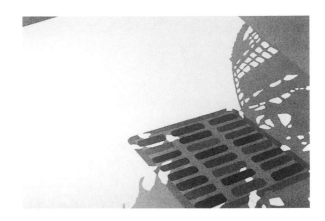

4 To develop the remaining area of the large dark shadow, Mehaffey cuts the frisket film around all of the small light shapes and carefully removes the large area of film that forms the shadow. He sprays the large shadow area with equal layers of Ultramarine Blue, Quinacridone Rose, and Cadmium Yellow, and adds more layers of both Cadmium Yellow and New Gamboge to the left side of the shadow away from the grate. Mehaffey adds variety and interest by removing some of the small frisket shapes and spraying a layer or two of New Gamboge.

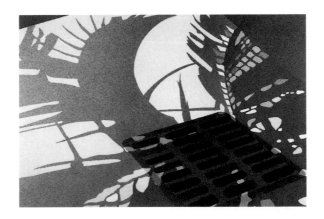

5 Mehaffey removes the frisket film, and gives the large areas of light which surround and infiltrate the darks three or four layers of Cadmium Yellow Light and New Gamboge. He removes the remaining small frisket shapes and sprays them with both yellows. Finally, he removes the film from the last of the small shapes, giving the design a full range of values from the white of the paper to the darkest dark in the storm grate.

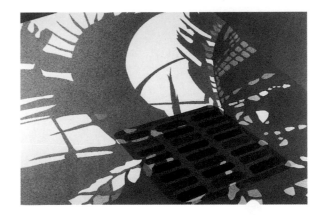

[aʀтɪsт's poʀтfoʟɪo]

"The technique will always be secondary

to the content."

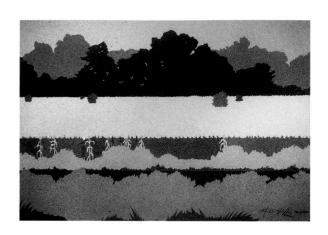

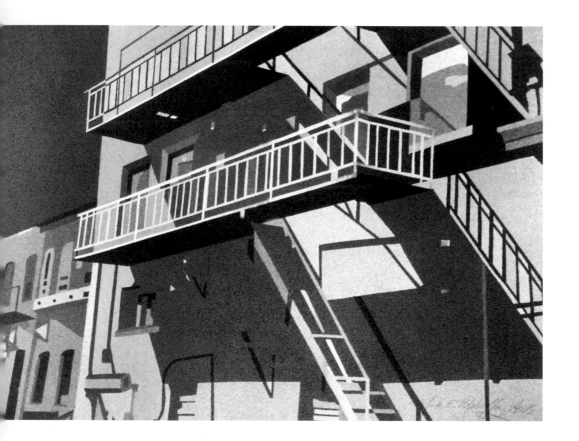

(top) **Seagulls and Corn**
18" x 27" (45.7cm x 68.6cm)
Technique: Spray painting with a mouth atomizer

(left) **Southern Exposure**
21" x 29" (53.3cm x 73.7cm)
Technique: Spray painting with a mouth atomizer

(right) **Northern Exposure**
22" x 30" (55.9cm x 76.2cm)
Technique: Spray painting with a mouth atomizer

(far right) **More Glads**
22" x 30" (55.9cm x 76.2cm)
Technique: Direct painting and spray painting with
a mouth atomizer

(bottom right) **A Child's Toy**
22" x 30" (55.9cm x 76.2cm)
Technique: Spray painting with a mouth atomizer

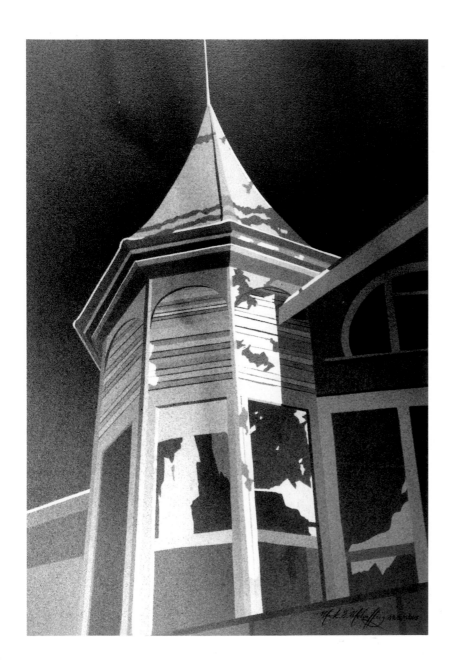

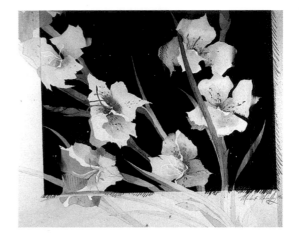

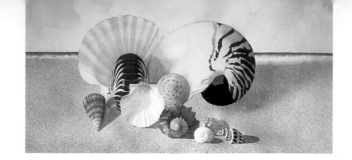

[s h o w c a s e]

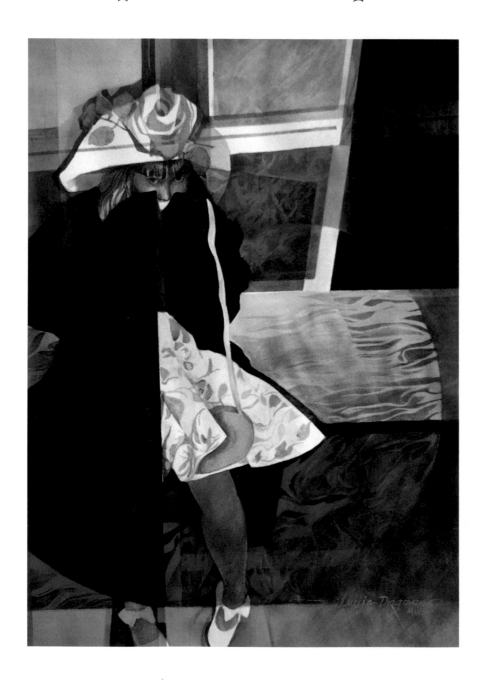

(top) Kay Dawson
Sea Shells
16" x 21" (40.6cm x 53.3cm)
Paper: Lanaquarelle 300# cold press watercolor paper
Technique: Airbrushing, spattering, direct painting

(left) Lucija Dragovan
My Daddy's Coat
30" x 22" (76.2cm x 55.9cm)
Paper: Arches 140# cold press watercolor paper
Technique: Repeated taping and painting, sponging, lifting

(top right) Joseph Melancon
El Roi Tan
40" x 30" (101.6cm x 76.2cm)
Paper: Crescent watercolor board
Technique: Throwing paint, glazing, spattering, lifting, direct painting

(bottom right) Joan Ashley Rothermel
Heron Haven
16" x 22" (40.6cm x 55.9cm)
Paper: Arches 140# cold press watercolor paper
Technique: Airbrushing, direct painting

(far right) Judi Betts
A Celebration of Life
22" x 30" (55.9cm x 76.2cm)
Paper: Arches 140# cold press watercolor paper
Technique: Patterns of light against darker values, overlaying to build color, lifting, scrubbing

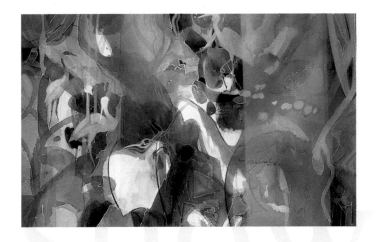

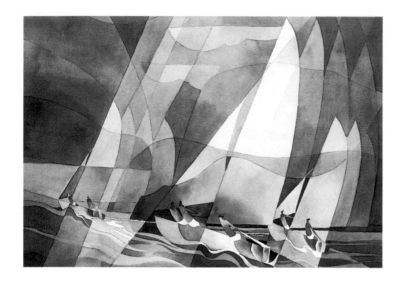

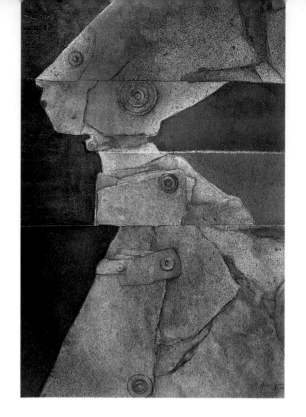

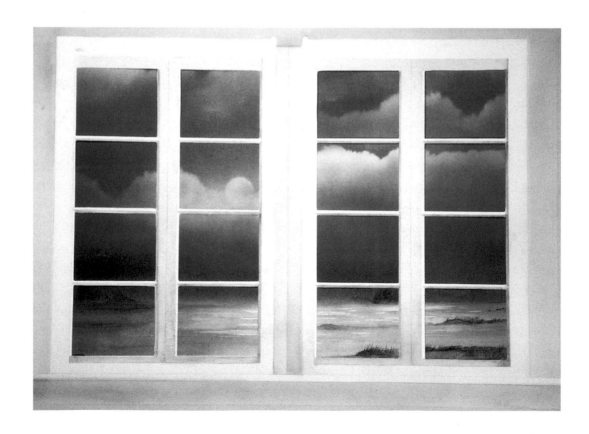

(top left) Aida Schneider
Nefertiti-Deconstructed
30" x 22" (76.2cm x 55.9cm)
Paper: Arches 300# cold press watercolor paper
Technique: Watermedia and oil pastel, texture, splattering, direct painting

(far left) Roy E. Swanson
The Regatta
22" x 30" (55.9cm x 76.2cm)
Paper: Arches 140# cold press watercolor paper
Technique: Resists, direct painting

(bottom left) Virginia A. Thompson
Moonrise
22" x 30" (55.9cm x 76.2cm)
Paper: Crescent watercolor board, Lana Aquarelle 140#
Technique: Airbrushing, collage

(top) Virginia A. Thompson
Ribbons #3
28" x 36" (71.1cm x 91.4cm)
Paper: Strathmore Aquarius II 80# cold press watercolor paper
Technique: Masking, spattering, acrylics, gouache, watercolor

(bottom) Aida Schneider
Nefertiti-Identity Crisis
22" x 30" (55.9cm x 76.2cm)
Paper: Arches 300# cold press watercolor paper
Technique: Watermedia, spattering, spraying, lifting, painting

*Bonny Lhotka is recognized for her groundbreaking work with acrylics,
collage, cast paper, and monographic transfer techniques. Her work has been
included in exhibitions of the American Watercolor Society, the National
Watercolor Society, the National Academy of Design, Watercolor USA, the
Butler Institute of American Artists, and Rocky Mountain National.*

"When I work with the computer, my approach is as unplanned as when I paint. Using the computer, I can save images at various stages as new ideas emerge and go back to try something else later. This opens up a level of risk taking because I never lose a good state."

-Bonny Lhotka

[computer creations]

"**K**nowing when to quit is the most difficult part of creating art on the computer." Computer-generated images are flooding our world. Some argue a piece of computer-generated work is not really art. Others say the computer is just another tool. Artists liken their computer and its software to a traditional artist's brushes, and an ink-jet printer to a mouth atomizer or airbrush. If the work created using an airbrush is art, why not work created using a computer? Bonny Lhotka's process of mixing traditional and digital tools closely relates to monotype because the image is first produced on a plate. In this case, the plate is digital. These paintings are original editions using a mixture of media.

{ Drydock }

MATERIALS

- Photographs - old window, brick siding, model ship
- Plexiglas scraps, .13-, .25-, and .5-inch pieces of clear Plexiglas for spacers
- 0.003 inch aluminum sheeting (for printing on the Iris printer)
- Aluminum foil • Vinegar • Etching press • Paint brushes • Scissors
- Soft vinyl plastic • Acrylic paint • Rives BFK Printmaking paper

Computer Equipment and Software:

- Macintosh computer • Adobe Photoshop 3.0 • Ofoto scanning software
- Hewlett Packard 550c • Flatbed 3-pass • Iris ink-jet printer
 waterbased ink-jet printer Microtek IIxe scanner • Syquest disk

Note: a wide variety of both software and hardware is available for use in the creation of computer art.

1 Lhotka will create a composition from 3-dimensional used objects in a new context. Small objects, when stacked on the scanner, can be captured at varying focus: She calls this process "digital watermedia collage." Digital collage requires a good supply of reference material to support the construction of complex images. Photographs of old buildings in a mountain mining town alley become the starting point for this demonstration.

2 The ship model shown here is over 100 years old. The print behind the model started with a Polaroid picture of the model. Lhotka scanned the picture and reworked it in Photoshop to create the look of a watercolor painting. She printed the image on watercolor paper. Compare the colors in the model ship and the "watercolor" of the ship. Lhotka uses Ofoto scanning software to predictably produce a consistent color match between reality (including artist's colors), her monitor, and her printers.

3 Lhotka uses the erase tool in Photoshop to remove the background of the "watercolor." Next, a mask for the ship is created using the Photoshop magic wand. The ship is captured as a separate selection. This prepares the image for integration into other work.

4 To create triangular shapes that will relate to the ship's sails, Lhotka begins with a sheet of crumpled aluminum foil. She washes the foil with strong vinegar to prepare it for painting. After receiving several layers of paint, the foil is dried. Finally, Lhotka cuts the painted foil into triangles.

5 Lhotka places the objects face down on the scanner bed. Objects are placed in order of their distance from the viewer. After placing the last object, Lhotka creates a flexible backdrop by painting a piece of clear soft vinyl plastic with green and yellow acrylics, and scraping lines into the paint as it dries. This backdrop is placed over the objects on the scanner.

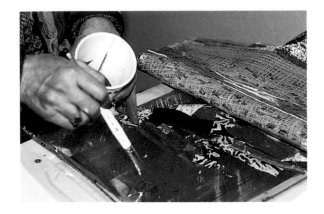

6 Lhotka next uses Plexiglas scraps to create layers of objects. She applies brush strokes to both sides of the Plexiglas. This gives extra depth to the scanned images as there are two different planes of color on each piece of Plexiglas. Unpainted areas on both sides appear to be white in this image. Lhotka uses the scanner bed as a 3-dimensional canvas. Since the image is scanned in three passes, she takes advantage of each step, painting Plexiglas lying on the scanner bed, moving objects during the scan, and adding and deleting objects during different scan passes. The scanner almost instantly records the images as ideas occur.

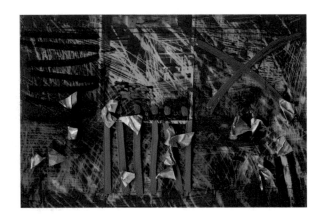

7 After the first pass, she adds the photo of the brick building. She removes the photo of the window after the second pass. The result of this first scan is shown here. In this and following steps, images are saved to digital files. The ability to save each scan and any interesting intermediate results frees Lhotka of all apprehension about experimenting.

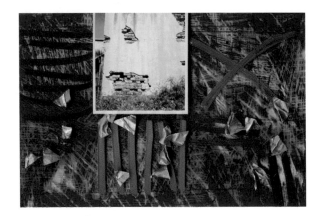

8 Lhotka repeats the scanning process to create another digital image. This time she puts the photo of the brick wall directly on the scanner. This brings the brick wall into sharp focus in the foreground of the scanned image.

9 Composition begins. Lhotka makes the ship transparent and stretches, shapes, and sizes it before pasting the image. She also pastes some of the grid from the original "watercolor" ship painting into the composition. Next Lhotka inserts the photograph of the window. She selects a portion of the scan for the composition.

10 In yet another scanning, a live pansy is scanned. She resizes, rotates, and changes the hue. Here, the computer is her tool to distort a natural object. Lhotka digitally paints the pansy in Photoshop. The pieces of the collage are assembled into the final composition. Using the digital brushes in Photoshop, Lhotka refines the details. The digital collage is saved to a Syquest disk for printing.

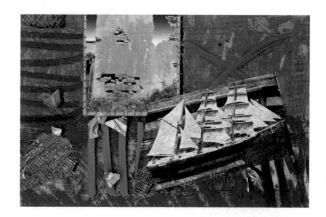

11 To add character to the paper, Lhotka distresses it. She wets the paper, crumbles it, flattens it in an etching press, and lets it dry. She coats the crinkled paper with iridescent pearl pigment and embosses the sheet in the etching press against a piece of burlap attached to plastic. For printing, she coats the sheet with an ink-jet receptor. Finally, Lhotka decides to re-emboss the burlap image on the paper to make the impressed pattern less regular. The final image is printed on an Iris ink-jet printer. The ink-jet sprays waterbased dyes onto the prepared watercolor paper with dots the size of a red blood cell. At this point the printed image can be reworked with pencil, pastels, or acrylics.

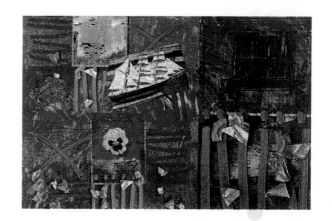

[аrтisт's portfolio]

*"The technique will always be secondary
to the content."*

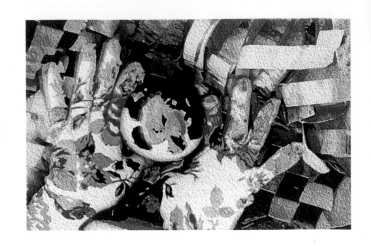

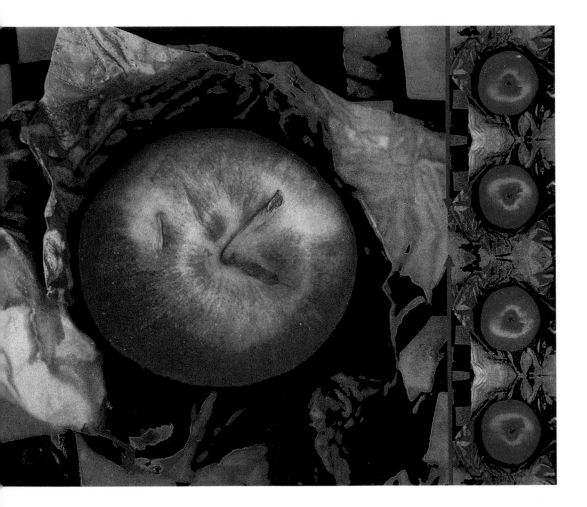

(left) **Fruit Box**
30" x 24" (76.2cm x 61 cm)
Technique: Digital watermedia collage

(top) **Magic Gloves**
24" x 30" (61cm x 76.2cm)
Technique: Digital watermedia collage

(top right) **DIA Airport**
16" x 26" (40.6cm x 66cm)
Technique: Digital watermedia collage

(right) **Jewel Box**
24" x 30" (61cm x 76.2cm)
Technique: Digital watermedia collage

(far right) **East/West**
24" x 30" (61cm x 76.2cm)
Technique: Digital watermedia collage

art

[s h o w C A S e]

(top) John F. Adams
Yellow Brick Road
30" x 22" (76.2cm x 55.9cm)
Paper: Arches 140# cold press watercolor paper
Technique: Strong personal statement, glazing, direct painting

(left) Warren Taylor
Royal Cyclamen
28" x 22" (71.1cm x 55.9cm)
Paper: Arches 400# rough watercolor paper
Technique: Strong personal vision of reality

(right) Jean Snow
Thru the Glass
19" x 15" (48.3cm x 38.1cm)
Paper: 90# watercolor paper
Technique: Collage, layering, charcoal, alcohol

(far right top) Carol Ann Schrader
Bandit Bands
29" x 21" (73.7cm x 53.3cm)
Paper: Arches 300# cold press watercolor paper
Technique: Strong personal statement, striped sheet

(far right bottom) Judy A. Hoiness
Land and Sea Series: Save Our Rivers and Mountains
22" x 30" (55.9cm x 76.2cm)
Paper: 300# cold press watercolor paper
Technique: Strong personal statement, shapes, type

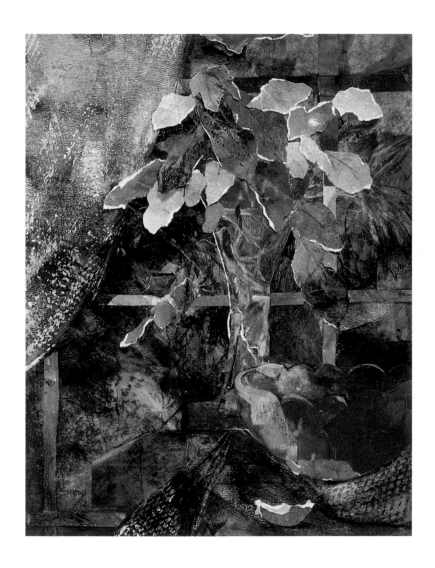

(top) Joyce Grace
Reflection on a Checkered Past
28" x 32" (71.1cm x 81.3cm)
Paper: Arches 300# cold press watercolor paper
Technique: Strong personal statement, direct painting, wet-on-wet

(left) Miles G. Batt
Half Dome Palindrome, Yosemite
29" x 22" (73.7cm x 55.9cm)
Paper: Arches 140# cold press watercolor paper
Technique: Strong personal imagery, direct painting, glazing

(top right) Miles G. Batt
Thunderclap Near the Sea of And
29" x 22" (73.7cm x 55.9cm)
Paper: Arches 140# cold press watercolor paper
Technique: Strong personal images, directly painted

(top far right) Igor Beginin
New Day
22" x 30" (55.9cm x 76.2cm)
Paper: Arches 140# cold press watercolor paper
Technique: Handmade colored paper, collage, direct painting

(bottom) Miles G. Batt
Lure of the Center
22" x 29" (55.9cm x 73.7cm)
Paper: Strathmore hot press watercolor board
Technique: Strong personal statement, direct painting, visual collage

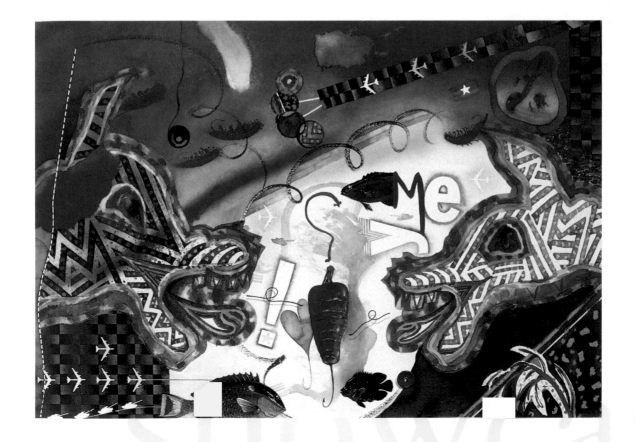

(left) Alex Powers
The Grandfather
40" x 50" (101.6cm x 127 cm)
Paper: Strathmore illustration board
Technique: Scumble lifting, charcoal, pastel, Xerox transfer

(bottom) Mary Alice Braukman
Keys to Imagination
15" x 30" (38.1cm x 76.2cm)
Paper: Crescent illustration board
Technique: Mixed watermedia, collage

(right) Alain Paul Briot
Moose Antlers and Isle Royale Landscape
16" x 20" (40.7cm x 50.8cm)
Paper: Arches 140# cold press watercolor paper
Technique: Photographs, computer-manipulated, printed
using watercolor

(far right top) Alex Powers
Pointing the Finger at Racial Injustice
19" x 33" (48.3cm x 83.8cm)
Paper: Strathmore illustration board
Technique: Charcoal, gouache, pastel, layering, strong
personal statement

(far right bottom) Elizabeth Concannon
Point of Departure
30" x 22" (76.2cm x 55.9cm)
Paper: Arches 300# watercolor paper
Technique: Collage, watermedia

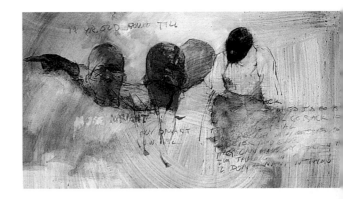

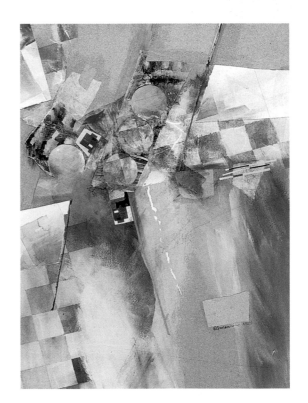

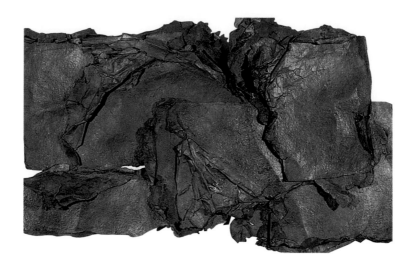

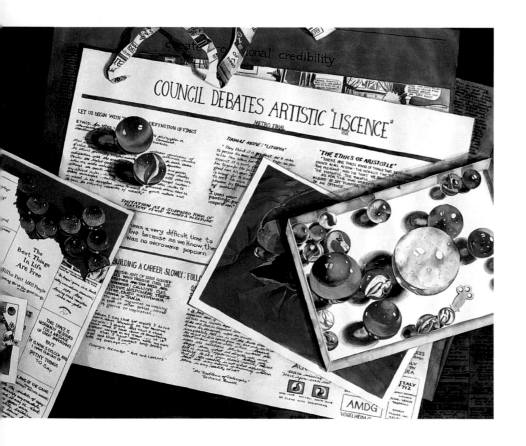

(top) Jean Deemer
Fractured
29" x 40" (73.7cm x 101.6cm)
Paper: 300# rough watercolor paper
Technique: Torn, acrylic, staining, collage

(left) Donna M. Vogelheim
Big Shooter: The Abduction
36" x 44" (91.4cm x 111.8cm)
Paper: Arches 140# cold press watercolor paper
Technique: Strong visual statement, direct painting, visual collage

(top right) Edwin H. Wordell
Not Far From the Ground
60" x 40" (152.4cm x 101.6cm)
Paper: Arches 240# rough watercolor paper
Technique: Collage, gouache, direct painting

(far right) Anne Wysocki
E & W 4.03
10.5" x 15.5" (26.7cm x 39.4cm)
Paper: Fabriano 50# watercolor paper
Technique: Computer-manipulated, printed using watercolor

(bottom) Anne Wysocki
Turning Themselves Almost…
10.5" x 15.5" (26.7cm x 39.4cm)
Paper: Fabriano 50# watercolor paper
Technique: Computer-manipulated, printed using watercolor

showcase

(top) Carrie Burns Brown
Patterns
8.5" x 10" (21.6cm x 25.4cm)
Paper: Rag mat board and tissue
Technique: Watercolor, staining, collage

(bottom) Jo Ann Durham
Red Triangles
28" x 36" (71.1cm x 91.4cm)
Paper: Solar Max
Technique: Collage-like, watercolors, metallics, Prismacolor pencils

(top right) Ann L. Hartley
Homecoming
12" x 12" (30.5cm x 30.5cm)
Paper: Arches 300# watercolor paper
Technique: Watermedia, collage with string, wood, paper, beads

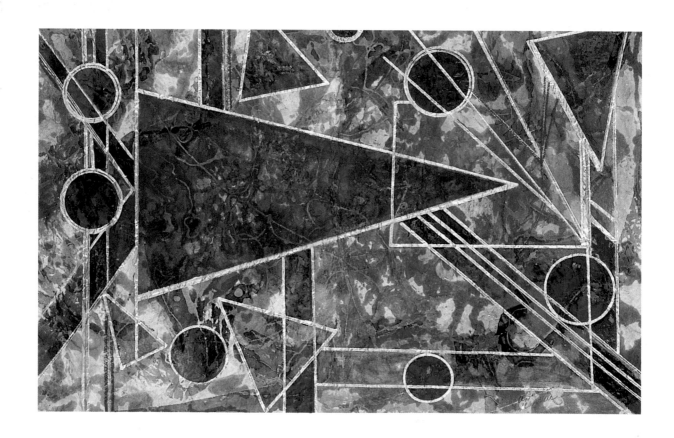

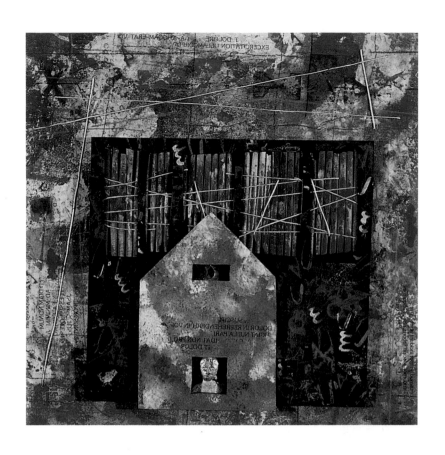

(far right) Alex Powers
Art Buddies
30" x 40" (76.2cm x 101.6cm)
Paper: Strathmore illustration board
Technique: Collage, watercolor, pastel, charcoal, layering

(right) Evie Roache-Selk
Joy in the Outback
11" x 17" (27.9cm x 43.2cm)
Paper: .25-inch untempered Masonite
Technique: Texture, overpainting, collage, beads

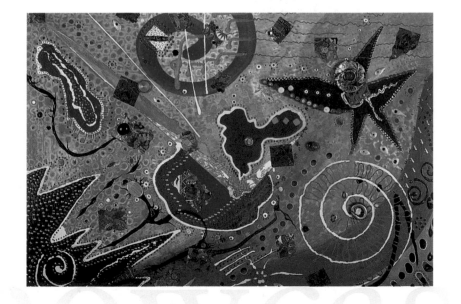

John F. Adams
5834 Ward Ave. NE
Bainbridge Island,
WA 98110
(206)780-2025

Dominique Yves Agnellet
4 Impasse Georges
LaFontaine, Lucon
France 85400
(01133) 51 27 9440

Gloria Miller Allen
3030 Sandstone
Idaho Falls, ID 83404
(208)524-2734

Rosemary S. Antel
3226 NW 67th. St.
Seattle, WA 98117
(206)781-3252

Bridget Austin
3033 Grande Rue
Green Bay, WI 54301
(414)336-7511

Anne Bagby
242 Shadowbrook Dr.
Winchester, TN 37398
(615)967-2437

Carmen Newman Bammert
9116 Buffalo Ct.
Flushing, MI 48433
(810)659-6201

Dorothy Watkeys Barberis
217 Lincoln Ave.
Elmwood Park, NJ 07407
(201)796-2546

Robert L. Barnum
9739 Calgary Dr.
Stanwood, MI 49346
(616)972-4214

Patricia Bason
8933 Tamar Dr. #301
Columbia, MD 21045
(410)964-8248

Miles G. Batt
301 Riverland Rd.
Ft. Lauderdale, FL 33312
(305)583-9207

Mary Ann Beckwith
619 Lake Ave.
Hancock, MI 49930
(906)482-1226

Igor Beginin
43524 Bannockburn Dr.
Canton, MI 48187
(313)453-3197

Judi Betts
P.O. Box 3676
Baton Rouge, LA 70821
(504)926-4220

Virginia Blackstock
3101 L Rd.
Hotchkiss, CO 81419
(303)872-2245

Marlene A. Boonstra
12901 Central Ave.
Crestwood, IL 60445
(708)385-7069

Jorge Bowenforbes
P.O. Box 1821
Oakland, CA 94612
(510)534-0177

Betty Braig
5271 S. Desert Willow Dr.
Gold Canyon, AZ 85219
(602)982-6610

Patricia Bratnober
2420 Stevens Ave S.
Minneapolis, MN 55404
(612)870-9921

Mary Alice Braukman
636 Nineteenth Ave. NE
St. Petersburg, FL 33704
(813)822-9628

Alain Paul Briot
214 Scallon Ave
Hancock, MI 49930
(906)482-3343

Al Brouillette
1300 Sunset Ct.
Arlington, TX 76013
(817)861-9311

Carrie Burns Brown
201 Hermitage Rd.
Greenbille, SC 29615
(803)244-0701

Marianne K. Brown
245 Rheem Blvd.
Moraga, CA 94556
(510)376-0658

Peggy Brown
1541 N. Claylick Rd.
Nashville, IN 47498
(812)988-7271

Mark D. Browning
2301 Pleasant Street
Miles City, MT 59301
(406)232-3771

Ken Landon Buck
1402 Greenup St. #1
Covington, KY 41011
(606)291-6480

Nancy S. Bush
213 Timberyoke Road
Moon Township, PA 15108
(412)264-4826

Don Carmichael
860 Stewart Street
Englewood, FL 34223
(813)474-4280

Leslie Clark
10888 Creek Rd.
Ojai, CA 93023
(805)649-4002

Virginia Cobb
Rt. 2, Box 310JF
Santa Fe, NM 87505
(505)471-4123

Elizabeth Concannon
12616 Villa Hill Lane
St. Louis, MO 63141
(314)434-4242

Kay Dawson
505 Summer St.
Eau Claire, WI 54701
(715)835-1393

Jean Deemer
1537 Briarwood Circle
Cuyahoga Falls, OH 44221
(216)929-1995

George W. Delaney
17 Champlain Ave.
Staten Island, NY 10306
(718)351-6316

Gayle Denington-Anderson
661 S. Ridge E.
Geneva, OH 44041
(216)466-8392

Patry Denton
2948 Pierson Way
Lakewood, CO 80215
(303)237-4954

Marilynn Derwenskus
3716 Lakeside
Muncie, IN 47304
(317)282-2759

Jane Destro
1122 10th. St. SW
Rochester, MN 55902
(507)288-5523

Ellen Jean Diederich
3374 Maplewood Ct.
Fargo, ND 58104
(701)235-4241

Lucija Dragovan
909 Summit St.
Joliet, IL 60435
(815)722-5017

Jo Ann Durham
4300 Plantation Dr.
Fort Worth, TX 76116
(817)244-3807

Pauline Eaton
68 Hop Tree Trail
Corrales, NM 87048
(505)898-1573

Marilyn Edmonds
Rt. 3, Box 72
Battle Lake, MN 56515
(218)864-8496

Lisa Englander
2512 N. Main
Racine, WI 53402
(414)681-2599

Rich Ernsting
6024 Birchwood Ave.
Indianapolis, IN 46220
(317)257-2691

Z.L. Feng
1006 Walker Dr.
Radford, VA 24141
(703)639-1273

Tom Francesconi
2925 Birch Rd.
Homewood, IL 60430
(708)799-8161

Frank Francese
1771 Stellar Place
Montrose, CO 81401
(303)249-6465

Yolanda Frederikse
9625 Dewmar Lane
Kensington, MD 20895
(301)942-0754

Kass Morin Freeman
1183 Troxel Rd.
Lansdale, PA 19446
(215)368-9882

Betty Grace Gibson
688 W. 100th. Ave.
Denver, CO 80221
(303)451-0379

Virginia L. Gould
347 Hiawatha Trail
Wood Dale, IL 60191
(708)595-7374

Joyce Grace
3403 Stonewall Rd.
Jackson, MI 49203
(517)784-9010

Jeannie Grisham
10044 Edgecombe Pl. NE
Bainbridge Island,
WA 98110
(206)842-9567

Sheila T. Grodsky
940 West End Dr.
Newton, NJ 07860
(201)383-5343

Marilyn Gross
374 MacEwen Dr.
Osprey, FL 34229
(813)966-4219

Carol A. Hammett
9135 Ermantrude Ct.
Vienna, VA 22182
(703)281-1308

Ann L. Hartley
13515 Sea Island Dr.
Houston, TX 77069
(713)444-1118

Noriko Hasegawa
3105 Burkhart Lane
Sebastopol, CA 95472
(707)829-9561

Jane Higgins
3170 Dolph
Ann Arbor, MI 48103
(313)996-4131

Judy A. Hoiness
1840 NW Vicksburg Ave.
Bend, OR 97701
(503)382-8697

Barbara J. Hranilovich
3422 Ridgefield Rd.
Lansing, MI 48906
(517)321-2917

Yumiko Ichikawa
1205 Clement St. #B
Radford, VA 24141
(703)731-9532

Bill James
15840 SW 79th Ct
Miami, FL 33157
(305)238-5709

Bruce G. Johnson
953 E. 173rd. St.
South Holland, IL 60473
(708)331-6850

Sam Knecht
P.O. Box 1
Grass Lake, MI 49240
(517)522-4136

Alex Koronatov
6520 Lucas Ave. #B
Oakland, CA 94611
(510)339-6855

Margaret Graham
Kranking
3504 Taylor St.
Chevy Chase, MD 20815
(301)654-3409

Chris Krupinskl
10602 Barn Swallow Ct.
Fairfax, VA 22032
(703)250-1650

Melanie Lacki
7962 Kentwood Way
Pleasanton, CA 94588
(510)846-2436

Incha Lee
713 W. Jacker Ave.
Houghton, MI 49931
(906)482-3330

Barbara Leites
18 Lehmann Rd.
Rhinebeck, NY 12572
(914)876-7357

Marilyn Gross

Bonny Lhotka
5658 Cascade Place
Boulder, CO 80303
(303)494-5631

Lorie M. Liebrock
2315 County Rd.
Calumet, MI 49913
(906)337-4205

Arne Lindmark
101 Forbus St.
Poughkeepsie, NY 12603
(914)471-1946

Maggie Linn
921 N. Front St.
Marquette, MI 49855
(906)226-3141

Edith Marshall
Rte. 1, Box 57-B
Hancock, MI 49930
(906)482-1790

Maxine Masterfield
3968 Lakeside Rd.
Sarasota, FL 33232
(813)346-0181

Wendy Mattson
2820 Miller Way
POB 1063
Placerville, CA 95667
(916)626-3963

Mark E. Mehaffey
5440 Zimmer Rd.
Williamston, MI 48895
(517)655-2342

Robert Lee Mejer
619 Meadowlark
Quincy, IL 62301

Joseph Melancon
9263 Biscayne Blvd.
Dallas, TX 75218
(214)320-1099

Carl Vosburgh Miller
334 Paragon Ave.
Stockton, CA 95210
(209)477-8302

Kathleen Conover Miller
3108 Lakeshore Drive
Marquette, MI 49855
(906) 226-2201

R. G. Millman
736 Brenda Ave.
Auburn, AL 36830
(334)887-6428

Jane Bertram Miluski
18 Brookside Rd.
Wallingford, PA 19086
(610)566-2546

Edward Minchin
54 Emerson St.
Rockland, MA 02370
(617)878-8181

Valerie Moker
100 McKee Cres.
Regina, Saskatchewan,
Canada, S4S 5N6
(306)584-5835

Elise Morenon
420 Fairview Ave. Apt. 3C
Fort Lee, NJ 07024
(201)947-7149

Sybil Moschetti
1024 11th. St.
Boulder, CO 80302
(303)442-8456

Carole Myers
12870 Ellsinore Dr.
Bridgeton, MO 63044
(314)739-2406

Shirley E. Nachtrieb
908 Ruth Dr.
St. Charles, MO 63301
(314)947-1936

Barbara Nechis
1085 Dunaweal Ln.
Calistoga, CA 94515
(707)942-5052

Lula Nestor
9865 Edward Dr.
Brighton, MI 48116
(810)227-4881

Thomas Nicholas
7 Wildon Heights
Rockport, MA 01966
(508) 546-2074

Maureen Nolen
2428 University Dr.
Newport Beach, CA 92660
(714)722-1155

Robert Nolin
238 Olympic Rd.
Pittsburg, PA 15236
(412)653-7293

Kim Seng Ong
Block S22, Hougang Ave.
6 #10-27
Singapore, 1953
(065)289-7377

Doug Pasek
12405 W. Pleasant
Valley Rd.
Parma, OH 44130
(216)845-2159

Ann Pember
14 Water Edge Rd.
Keeseville, NY 12944
(518)834-7440

Marietta Petrini
5101 Val Jean
Encino, CA 91316
(818)981-6099

Carlton Plummer
10 Monument Hill Rd.
Chelmsford, MA 01824
(508)256-7937

Carol Lynn Pohl
401 W. Fullerton 202E
Chicago, IL 60614
(312)871-9222

Mary Ann Pope
1705 Greenwyche Rd. SE
Huntsville, AL 35801
(205)536-9416

Alex Powers
401 72nd. Ave. N. Apt. 1
Myrtle Beach, SC 29577
(803)497-7204

M. E. Procknow
1201 Cozby East
Fort Worth, TX 76126
(817)249-1461

Judith S. Rein
0064 W. Greenlawn Dr.
La Porte, IN 46350
(219)362-1390

Patricia Ritter
2518 Saratoga Dr.
Louisville, KY 40205
(502)499-0000

Evie Roache-Selk
PO Box 239
Jemez Springs, NM 87025

Joan Ashley Rothermel
221 46th. St.
Sandusky, OH 44870
(419)629-2959

Michael Schlicting
3465 NE Davis St.
Portland, OR 97232
(503)235-6978

Aida Schneider
31084 E. Sunset Dr. N.
Redlands, CA 92373
(909)794-4487

Carol Ann Schrader
113 E. Harbor Dr.
Hendersonville,TN 37075
(615)824-7971

Mei Shu
1006 Walker Dr. #A
Radford, VA 24141
(703)639-1273

Catherine Wilson Smith
9N273 Oak Tree Lane
Elgin, IL 60123
(708)464-5485

Patsy Smith
821 Apache Dr.
North Platte. NE 69101
(308)532-0158

Rowena M. Smith
5313 Bayberry Ln.
Tamarac, FL 33319
(305)731-3713

Jean Snow
4 Charlotte Dr.
New Orleans, LA 70122
(504)283-3171

George Sottung
111 Tower Rd.
Brookfield , CT 06804
(203)775-6708

Barbara St. Denis
196 Doberman Tr.
Easley, SC 29640
(803)855-2570

Colleen Newport Stevens
8386 Meadow Run Cove
Germantown, TN 38138
(901)755-1518

Pat Strickler
121 Kaskaskia Ct.
East Peoria, IL 61611
(309)694-7806

Roy E. Swanson
10409 E. Watford Way
Sun Lakes, AZ 85248
(602)895-7337

Fredi Taddeucci
Rte. 1, Box 262
Houghton, MI 49931
(906)482-4656

Warren Taylor
P.O. Box 50051
Midland, TX 79710
(915)685-4651

Virginia A. Thompson
10776 SW 88th. St., #F-21
Miami, FL 33176
(305)830-8392

Nedra Tornay
2131 Salt Air Dr.
Santa Ana, CA 92705
(714)544-3924

Glenda VanRaalte
14304 104th. Ave.
Grand Haven, MI 49417
(616)846-8687

Donna M. Vogelheim
36419 Saxony
Farmington, MI 48335

Tony J. Warren
14719 Crofton Dr.
Shelby Twp., MI 48315
(810)247-0915

Lee Weiss
106 Vaughn Ct.
Madison, WI 53705
(608)238-2830

Elaine Wentworth
132 Central St.
Norwell, MA 02061
(617)659-2910

Murray Wentworth
132 Central St.
Norwell, MA 02061
(617)659-2910

Terry Wickart
3929 65th. St.
Holland, MI 49423
(616)335-3511

Genie Marshall Wilder
102 Horseshoe Lane
Clinton, SC 29325
(803)833-3658

Joyce Williams
Box 192
Tenants Harbor, ME
04860
(207)372-6904

Donna Jill Witty
444 N. Hill St.
Woodstock, IL 60098
(815)338-0849

Edwin H. Wordell
6251 Lorca Dr.
San Diego, CA 92115
(619)286-1328

Anne Wysocki
214 Royce Rd., Ripley
Hancock, MI 49930
(906)487-9408